D1157722

Symbols of Endurance

Marlon Griffith
Symbols of Endurance

**black dog
publishing**

london uk

Contents

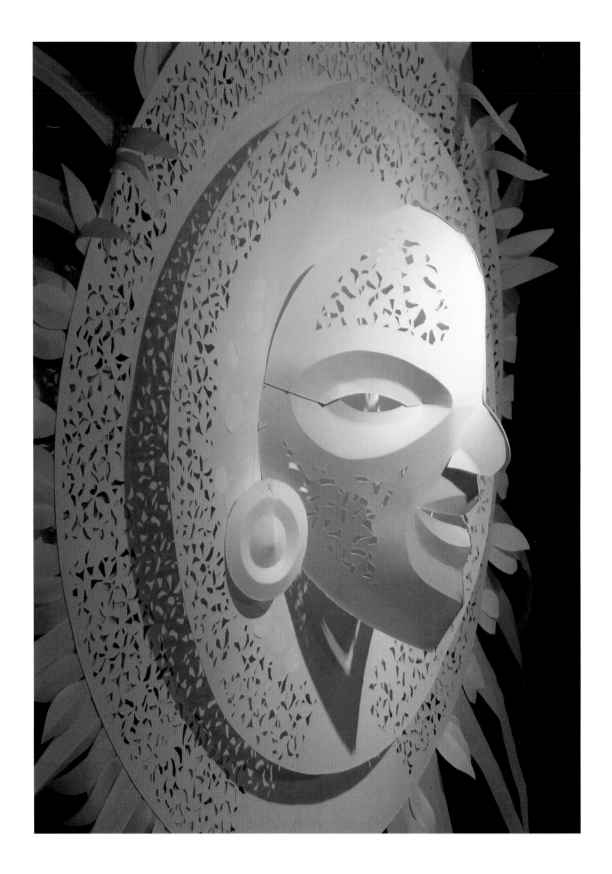

SUN, 2005, washi
sculpture, Mino,
Gifu, Japan

On Splendour: Elements of a Procession (for Marlon Griffith)

Gabriel Levine

We shall not define with one concept the splendour that glitters and resounds under Mount Hagen, in the liturgical processions in Byzantium and the high mass of Medieval cathedrals, in the Negara, the theatre-state of old Bali, in Carnival in Rio de Janeiro—in the plumage and dance of the Great Argus pheasant, in the sun's gold spread over the blue oceans, in the fisherman rowing with golden oars...

—Alphonso Lingis, *Violence and Splendor*

I bow to the economic miracle, but what I want to show you are the neighbourhood celebrations.

—Chris Marker, *Sans Soleil*

Sound

First comes sound, the sound you hear from a distance: a clatter or whisper or murmur or thunder. From across the hills, in the canyons of rock, through tall grasses, under the roof of the great tent or the house of worship, through alleys of concrete and mirrored glass, a blasting or chiming or drumming or ringing or humming. This time, it's the heartbeat drum and high-raised voices, the marshals shouting through megaphones, the spitfire poetry of courage and truth. Other times it's trombones and trumpets with sonorous blasts, or the cyclical bells of the gamelan, or unison chants extended by interior space. Often, in an urban procession, it's bass frequencies carried by sound systems on flatbed trucks. From far away, in all cases, there is a muffled resonance that quickens the heart, an echoing that carries from a distance. Hurry, they're just around the next corner! You move to find an opening through the crowd. And when you are in the middle, in the thick of the procession, the sonic matter throbs inside your bones.

Perhaps you are walking, or rolling on wheels, or dancing, or prostrating, as the sound carries your body along with other bodies. Sound turns a stroll into a procession. Sound communicates, shudders, connects, pouring across the borders of the self. The "agency distributed around a vibrational encounter" allows the procession to do its work.[1] But even silence creates its own vibrational space, in the midst of an urban cacophony or the calm of the field or sanctuary. In silence, often there are candles burning, deaths to mourn. Your heart is beating, a cough echoes, kids whine, crickets chirp. A crowd tracks its own pulse, breath and movement working together in subtle syncopation.

1 Goodman, Steve, *Sonic Warfare: Sound, Affect, and the Ecology of Fear*, Cambridge, MA: MIT Press, 2010, p 82.

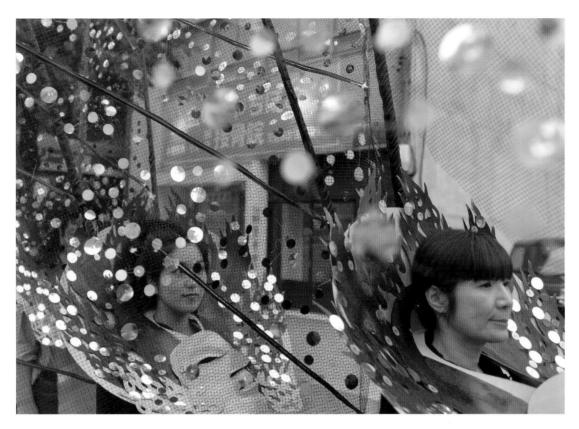

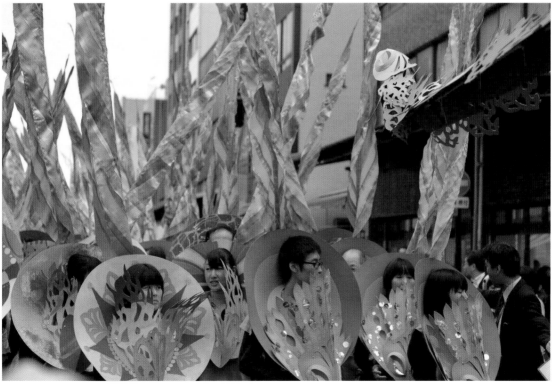

This page and opposite:
Song of the Sun, 2013,
Nagoya, Japan

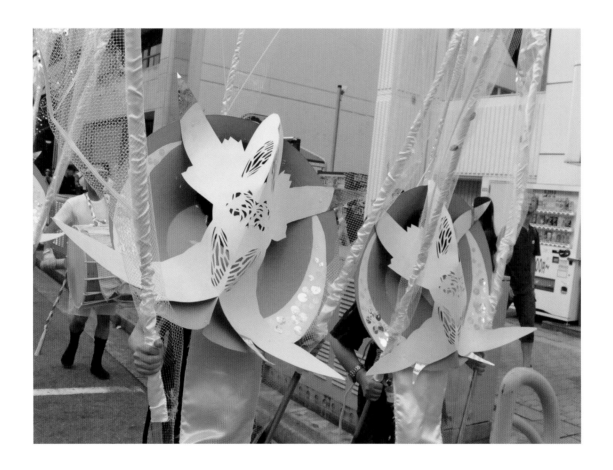

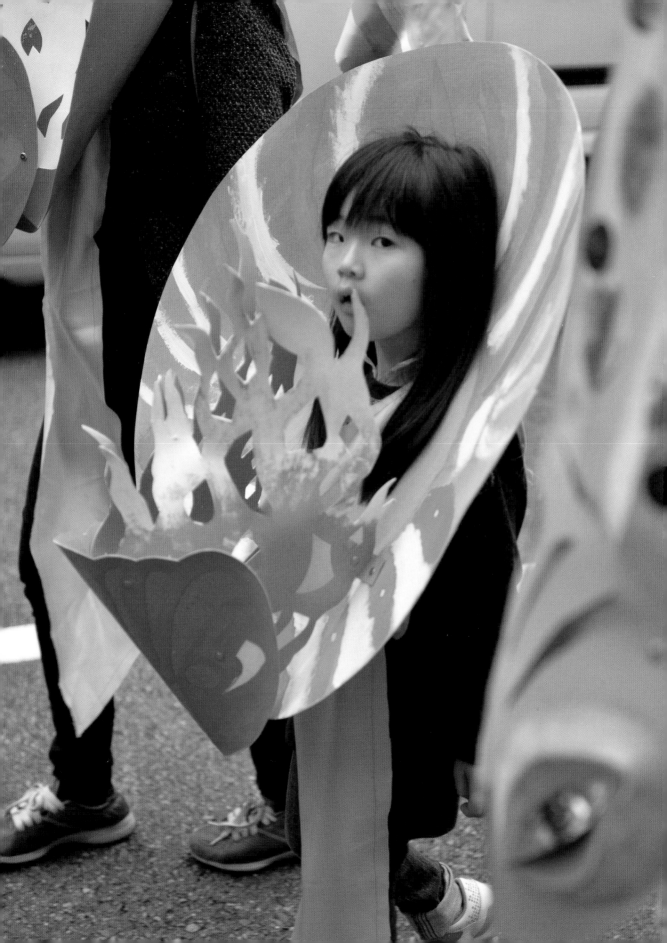

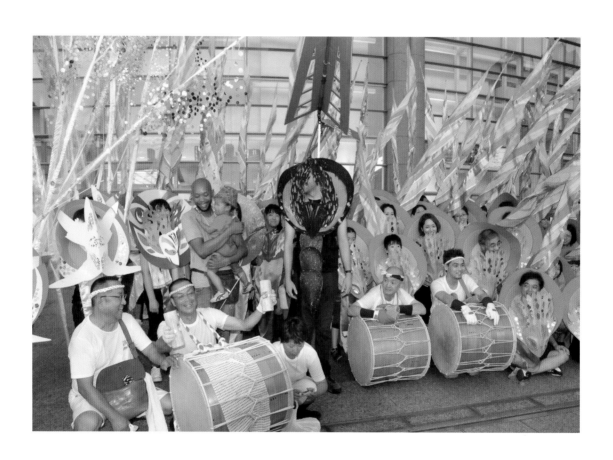

Opposite, below and
pp 14–15: *Song of the Sun*,
2013, Nagoya, Japan

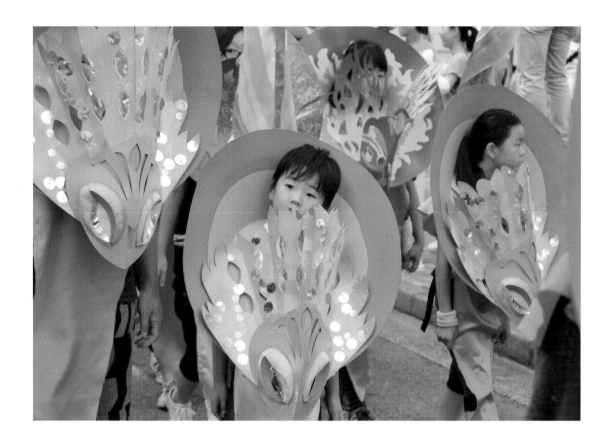

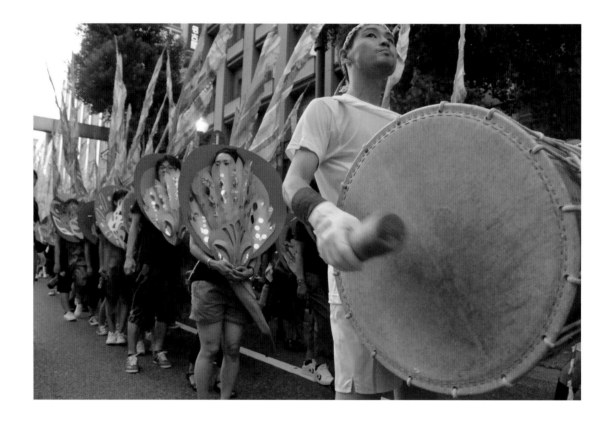

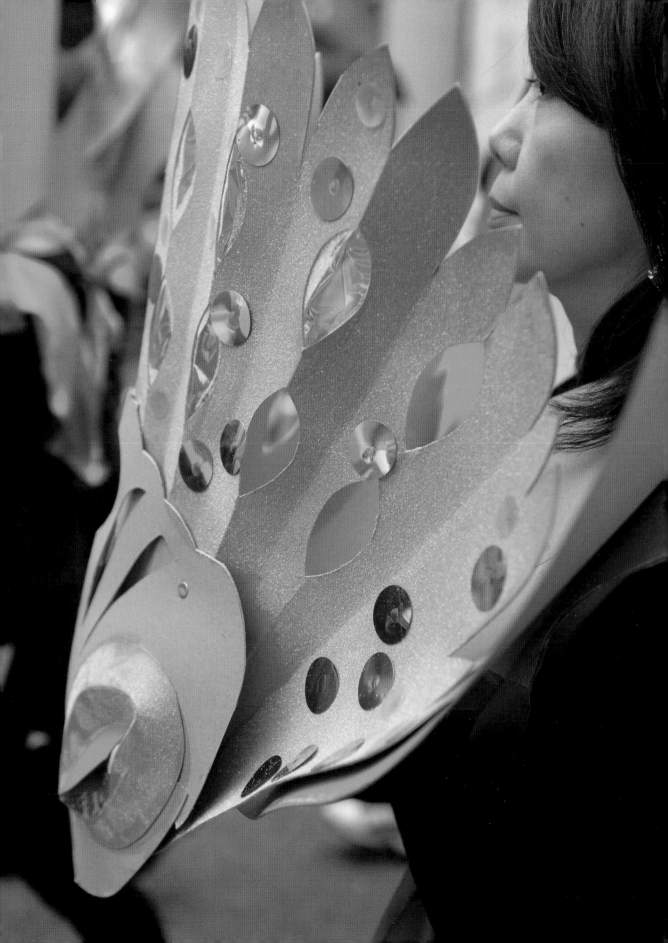

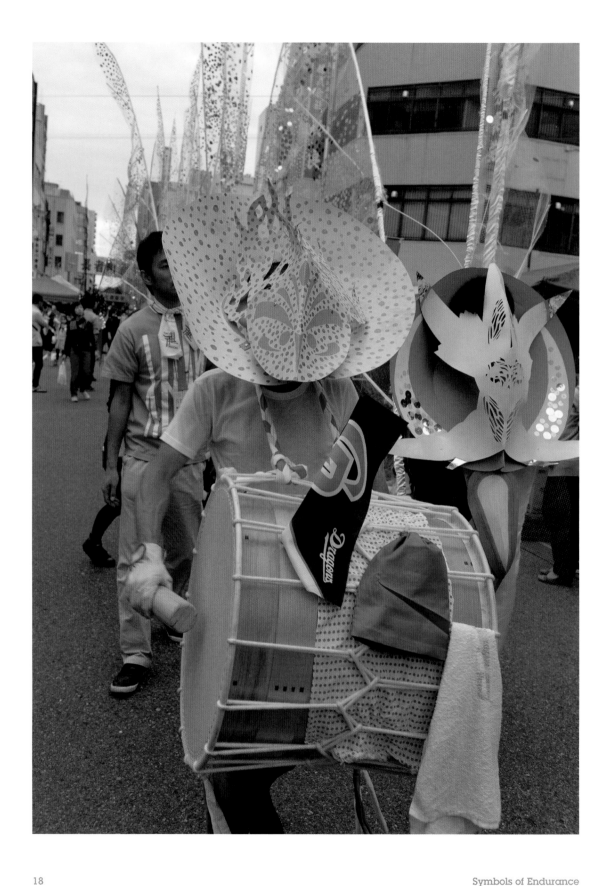

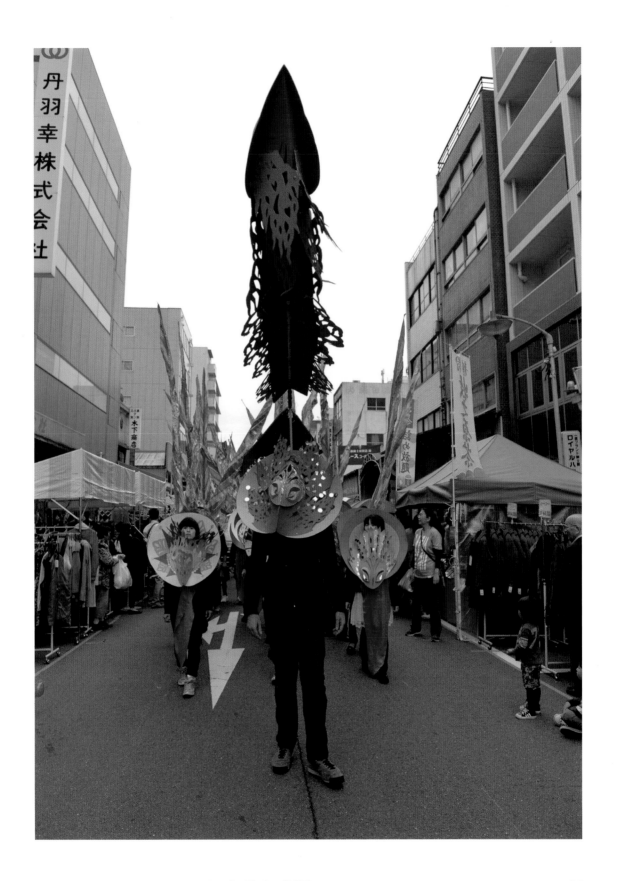

On Splendour: Elements of a Procession (for Marlon Griffith)

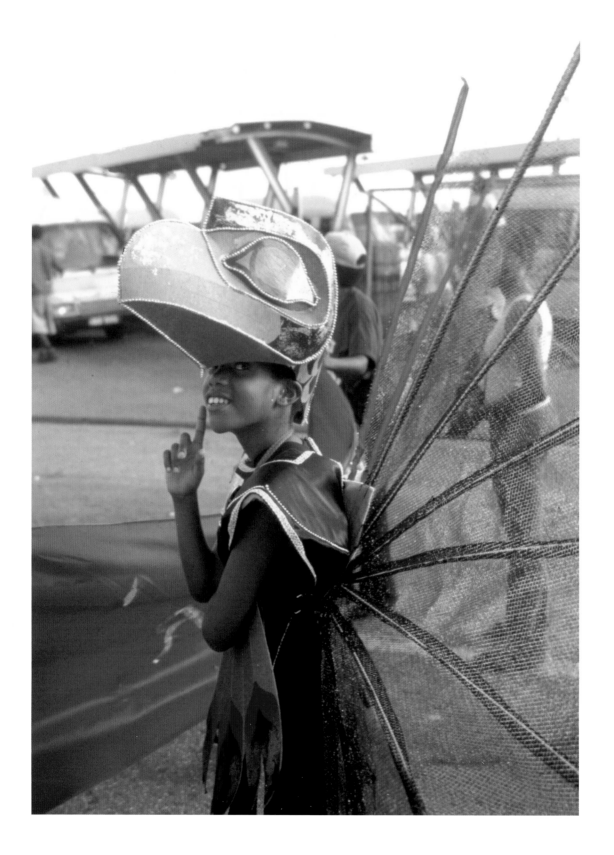

Arrow to the Sun:
Messenger of the
Gods, 2005, Port
of Spain, Trinidad

Movement

Why this desire to move in groups, to extend through space, to accumulate and display in collective glory? Life, it seems, needs to move. "We advance by placing one foot in front of the other; other creatures, like the leech, by drawing the body together; others, like the infusoria, slither along by the aid of cilia; and all of these movements are dependent upon totally different principles. Yet the ideal aim of attaining what is necessary for life by a change of place is in all cases the same."[2] But the movement of a procession does not stem from necessity or scarcity. On foot, borne by animals, in chariots or floats, in self-propelled or motorized vehicles, a procession moves with excess life, an abundance that calls for a response.

The excess carried by a procession appears in many forms. It might be the spoils of war, borne by the victors in triumphal marches over the prostrate bodies of the defeated (to be memorialized in stone on triumphal arches). It might be the turbulence of bodies in the street, raising voices and placards, or weapons, and moving to the centre of power. It might be the floats of the consumer holiday parade, the turkeys and Santas filled with animate gusts of hot air, gliding like stately dignitaries. Or it might be the regalia and rhythmic steps of a Pow-Wow's grand entry, dancers and veterans and elders expressing their belonging, splendour, memory and pride. Whatever the excess, the procession puts it to movement, sets abundance in motion for the purposes of dominance or rebellion or veneration or collective remembrance and joy.

The procession moves forward in a steady rhythm, a moderate rolling or walking pace. Forward, always forward—only rarely backward, in a ritual inversion with special significance (the end of the Jewish Sabbath is sometimes marked by walking backward). Forward in a circle, or in a straight line, depending on the procession's cosmological form. To move forward expresses confidence in the endurance of the symbols that you carry. A steady forward movement means endurance in time: look at us, we are not going anywhere, even as we move along.

Within the frame of the procession's steady movement are rhythmic phrases that reinforce or complicate its forward flow. Here processions diverge along the axis of dominance. The rhythms of military parades

2 Fechner, Gustav Theodor, *Nanna, or the Soul of Plants*, 1848, quoted in Spyros Papapetros, "Movements of the Soul: Traversing Animism, Fetishism, and the Uncanny", *Discourse*, vol 34, nos 2–3, 2012, p 188.

are as tightly calibrated as the weapons carried by marching officers and soldiers. They are on the beat, snapped to a grid. (In the nineteenth century, working-class militias echoed these displays of martial splendour, parading uniforms, cannons and rifles raised by popular subscription through the streets of Paris and Chicago.) Carnival processions tend toward a looser syncopation, allowing for improvisation and personal rhythms, playing in and out of the forward movement of the whole. There are endless rhythmic variations, as the tight order of a high school colour guard slides into the loose improvisation of a New Orleans second line. Circles within circles, as the procession moves along.

Top: *Arrow to the Sun: World of Men*, 2005, Port of Spain, Trinidad
Bottom left: *Arrow to the Sun*, 2005, Port of Spain, Trinidad
Bottom right: *Arrow to the Sun: World of Beauty*, 2005, Port of Spain, Trinidad

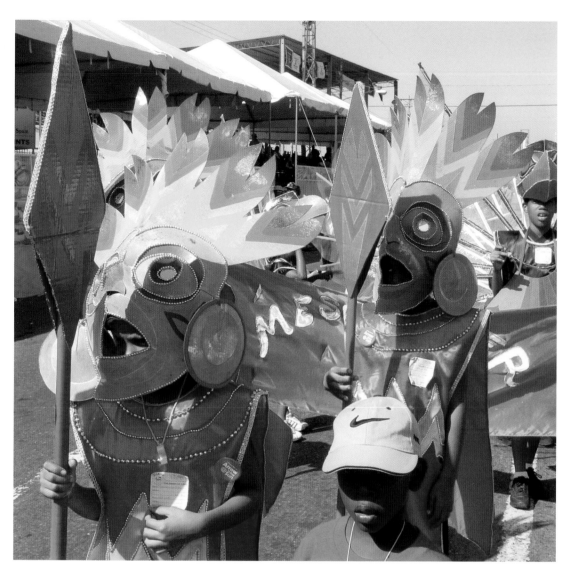

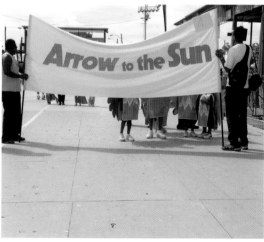

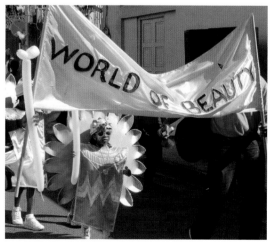

Height

As a witness to the movements of a procession, you can stay on the sidelines—upright behind a metal barrier, leaning from a balcony, seated on a plastic chair or woven mat, peering between the heads of taller folk. As a stationary spectator, the procession moves by you (if it is circular, it moves by you multiple times); you take in the movement from a fixed point. If the physical and ritual barriers are down, you might be tempted to join in, become part of the flow, add your own rhythm to the rhythms of the group. At some point, you might step back out, climb a tree or a street lamp, get hoisted on an adult's shoulders, so you can view it from above. From a height, the procession's movement reveals itself, as you watch the trailing bodies move, snake-like, through profane or sacred space.

Height is the axis of the procession's upward reach. Flags wave in the air; people wave from moving platforms. Floats float; effigies dangle; plumes and placards sway. The procession stretches upward as it moves, its participants mounted on horses, elephants, stilts, trucks, tanks. Elevation is practical; height allows the crowd below to witness the procession's glory. But height is also the very dimension of power and splendour. Height leaps out of the everyday, opening up extraordinary time and space, the sphere of ritual or festivity. Height is transcendent, but also collective, establishing a new horizon. Eyes look up to see what's above and, in so doing, eyes meet each other in a moment that might be one of recognition, laughter, menace, flirtation, or rebellion.

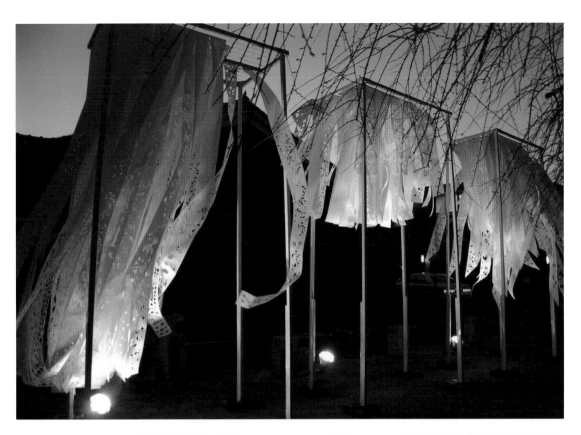

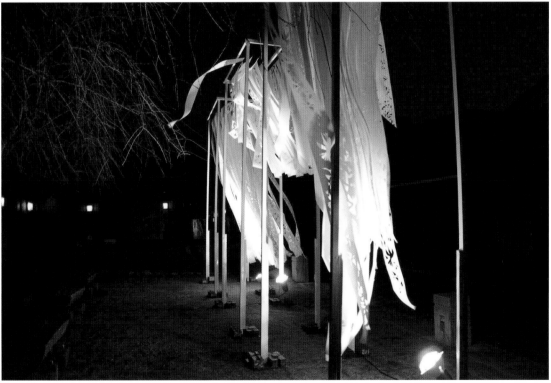

KING
(FUTURE)

WISDOM

QUEEN
(LOVE)

ACT I

This page and opposite:
Ring of Fire concept
sketches, 2015,
marker on vellum

RESPECT

ACT II

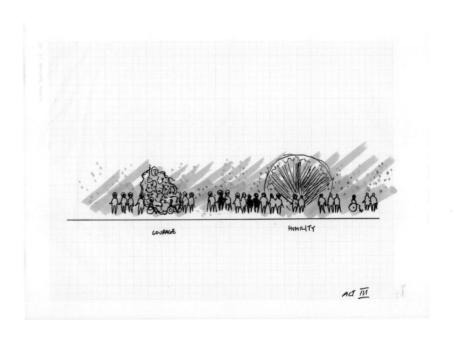

COURAGE

HUMILITY

ACT III

Adornment

Those same eyes might also look out from behind a mask, gleaming as a part or the whole of the face is obscured. A half-mask leaves the mouth free to sing, to talk or to kiss; a full mask transforms the face into an emblem. A full mask is the stationary symbol around which the body plays in a dance of animation. In the form of multiples, identical or similar, masks bring individuated humans into a shared existence beyond the human. Masks and a few scraps of fabric create groups of sunflowers, peacocks, ancestors, orators, clowns, mythical beasts, chickens. Multiple masks turn an expressive "I" into a "we" that extends into the animal, the mineral, the cosmic, the ridiculous. Even a simple piece of fabric drawn below the eyes lets the body find new possibilities of courage, aggression, disinhibition, or solidarity.

A mask puts the skin of the face in contact with other materials: wood, paper, plastic, cardboard, cloth. These materials are then shaped and adorned with figures and patterns that expose human bodies to wider animating forces. Here, a seed bursts into feathered glory, looking for a wind to carry it to a new home; veins wind through a leaf, as the energy of chloroplasts pulses from stem to tip. The negative space of patterns is a gateway into "the sympathy of things".[3] Yet, in contact with a mask, you also feel a material resistance. On a hot day, pressing against your face, the mask makes you sweat. When you speak inside it your voice echoes back, returning to yourself as you temporarily adopt the aspect of another being.

The drive to adornment carried by the procession moves outward from the mask, expanding into costumes, bodily extensions, and architectural forms. Bodies become icons, avatars, symbols. Wings swoop up into the sky; delicate costumes extend human figures into swaying aureolae. Adornment can spiral out into fractal filigree, or it can congeal into geometric shapes. Circles, chevrons, and arrows, with their clear outlines, compete with feathers, capillaries, and winding script. Geometry takes the excess of adornment and distils it to an essence, a potion boiled down to a thick syrup. All around us float the distillations of this excess: the golden arches, the swift swoosh, the nibbled apple. We need new badges, new emblems, to help redirect commodified excess into a collective power and splendour.

The procession moves in shape, sound, and colour. Colour is the medium of a procession's adornment, not an addition after the fact.

3 Spuybroek, Lars, *The Sympathy of Things: Ruskin and the Ecology of Design*, New York: V2 Publishing, 2011.

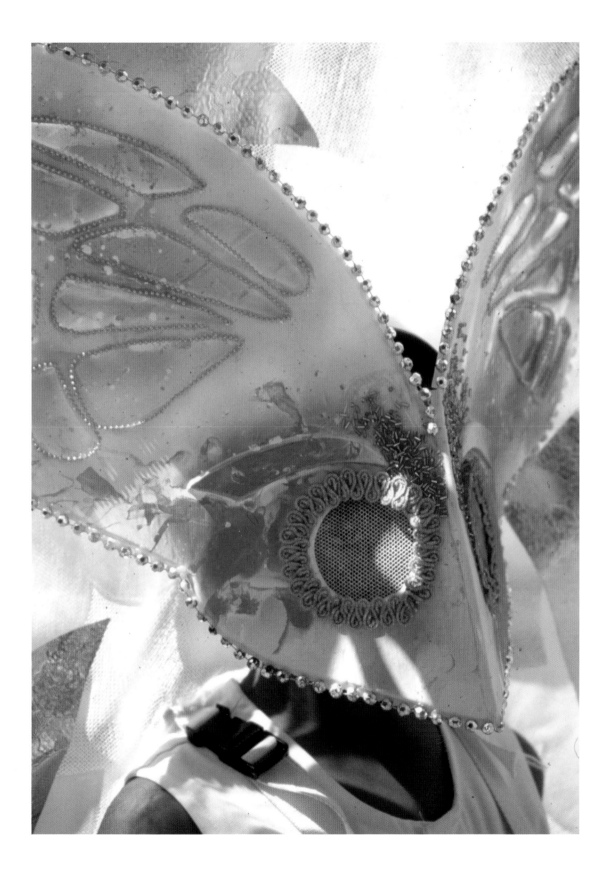

Colour *moves*. Colonial modernity assigned colour to the world of contagion, animism, and the irrational, while rushing to extract colour from living organisms, and then to synthesize it from coal and oil waste.[4] To produce the adornment of colour, a vibrating frequency is harnessed into paint and dye. Colour is splendid, from the Tyrian royal purple secreted by the glands of sea snails—250,000 of them crushed to make an ounce of dye valued higher than gold—to the *drapeau rouge* carried above workers' processions. The splendour of colour is captured in uniforms and regalia, in flags and masks. In a procession, masses of colour define groups and principles embedded in history and in creation, like the yellow and black and red and white of the Anishinaabe medicine wheel. The procession vibrates in colour as well as in sound, inviting you to participate in its adornment, to join its moving splendour.

Top: *POSITIONS+POWER*, 2014, Port of Spain, Trinidad
Bottom: *Ring of Fire*, 2015, Toronto, Canada

4 Taussig, Michael, *What Color is the Sacred?*, Chicago: University of Chicago Press, 2009.

Symbols of Endurance

Production

To the observer or casual participant, the procession seems ephemeral, transitory—a fleeting materialization of excess that will vanish at the end of the route. But if we move to the level of production—the mas' camp, the studio, the sewing table, the workshop—we see a different story. In the production of materials, the festive time of the procession extends on either side, from the months of preparation to the aftermath of storage and dispersal. A dancer might lovingly sew a costume in isolation, adorning it with patterns and colour while anticipating the moment of display, then, when the parade is over, fold it carefully for another year. Groups might pull old processional structures and materials out of the attic, breaking them into pieces and adapting them to a new theme.

The mas' camp, where carnival elements are designed and fabricated, is one model of processional production. In the mas' camp, collective work is organized around stations and tasks, with varying degrees of hierarchy or autonomy. Sometimes this work is done on commission, but often shared labour is its own reward. In the studio, music is playing, there is conversation and food, while helpers move from task to task. By harnessing collective labour-power outside of the order of capital, the mas' camp demonstrates "the potential of carnival to function as a production system".[5] Carnival is often thought of as pure expenditure or symbolic transgression, but its production enacts a different kind of economy. In carnival production, value is not extracted from cheap labour and cheap nature. Rather, value coalesces in new configurations of materials and practices, directed toward the goal of collective appearance.

The materials involved in the production of a procession might not be cheap. An official procession might carry golden chalices and icons, or expensive military gear. But the processions that are rooted in vernacular invention tend to work with cheap, recycled, and cast-off materials. Cheapness, processional artists know very well, is at the heart of splendour. Splendour radiates from the cheapness of the sun and the wind, the abundance and joy that flows through creation. The production of a procession can be a site where this joy emerges, in the making of a shared world out of things of little market value.

5 Tancons, Claire, "The Greatest Free Show on Earth: Carnival from Trinidad to Brazil, Cape Town to New Orleans", *Prospect.1 New Orleans*, Barbara Bloemink et al eds, New York: Picture Box, 2008, p 52.

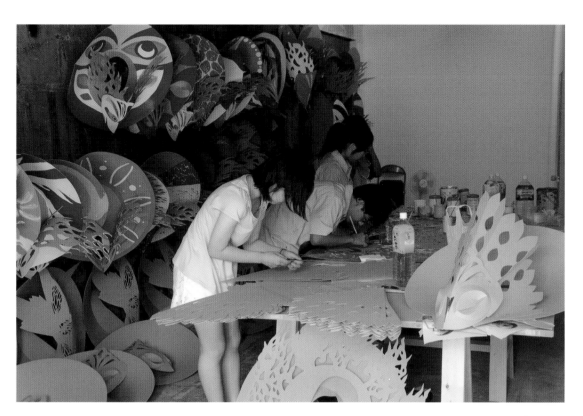

On Splendour: Elements of a Procession (for Marlon Griffith)

Power

The military or police procession is staged to inspire awe and fear. Here, processional elements that can express splendour—sound, movement, height, adornment—are mobilized in the service of dominance. The masks and shields of the riot squad are multiples, hiding faces and turning bodies into weapons, allowing truncheons to swing without scruple. Horses put their riders high above the crowd; the rumble of helicopters and the wail of sirens carry across a distance. The rare flashes of colour in a military parade only remind you how colour has been stripped from warfare, replaced by monochrome and camouflage. Splendour has given way to "shock and awe", a destruction that is terror without glory.

In joyful processions, however, power lifts up rather than weighs down. Walking or marching or dancing, your spirits rise along with the procession's rhythmic movement. Filled with power, you might adorn yourself in martial finery, with forms that recall the antlers of a stag or the claws of a bear. You might process with arrows in your back, bearing a transparent shield that exposes and protects you at the same time. A history of invasion by naval warships might lead you to dress as a sailor in a riot of sashes and brocade. You might play brass instruments that were picked up from marauding armies, steel pans that once were cast-off pot lids and oil drums, or pots and pans taken from your kitchen. You might carry banners and flags that show you belong to a collective, a group that has power and endurance. As you process together, you take up space; for a moment, the city bows before you, pays you homage.

The procession, in its splendour, carries the joy of production into a demonstration of collective power. Marcus Garvey knew this as he glided through Harlem in his parading car, dressed in ornate regalia and surrounded by uniformed supporters. The social aid and pleasure clubs of New Orleans extended the power of the procession into collective care, ensuring proper burials for their members. The procession's power arises from collective discipline as well as joy. It can be a relaxed discipline that allows for improvisation and adaptation. On a scorching summer day, you might need to lift your mask to protect the top of your head, as you walk through the city's sunbaked canyons. Your costume might be half-improvised, as you carry bags for water and supplies. You could move in whatever way feels right at the moment, or you could train with the others, practise your choreographies and rhythms until they are tightly synchronized. Either way, you are there with others, familiar or strange, multiplying your power in sound, shape, colour, and movement, collectively bearing and becoming symbols of enduring splendour.

Above: *No Black in the Union Jack* concept sketches, 2014, digital drawing
Opposite: *No Black in the Union Jack* concept sketch, 2014, wax pencil on black paper

Symbols of Endurance

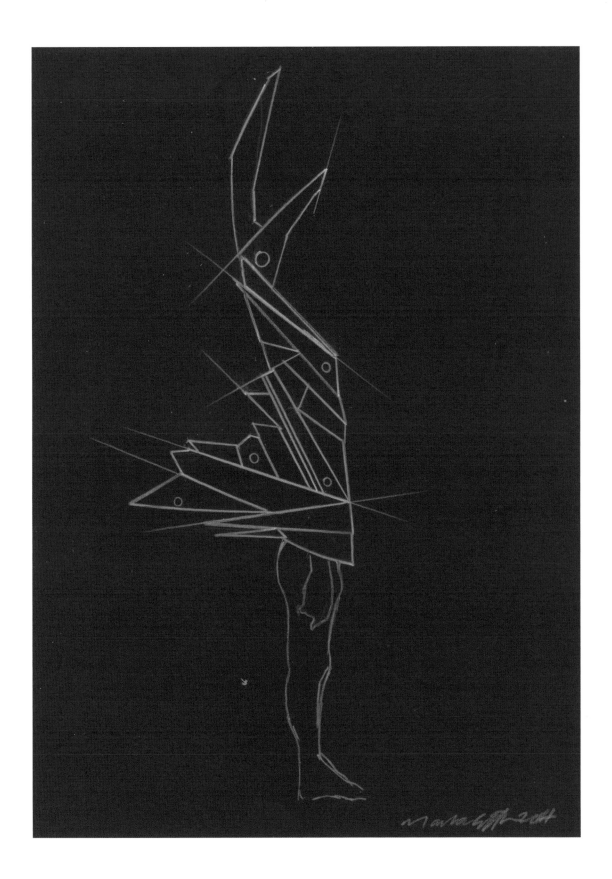

On Splendour: Elements of a Procession (for Marlon Griffith)

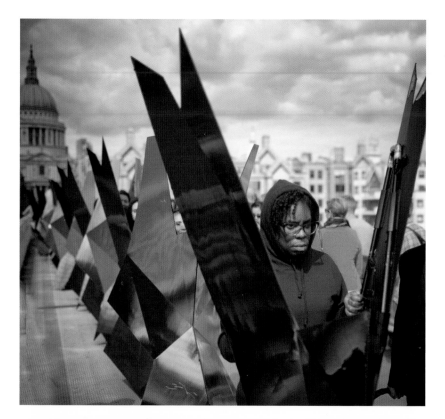

This page and opposite:
No Black in the Union Jack,
2014, London,
United Kingdom

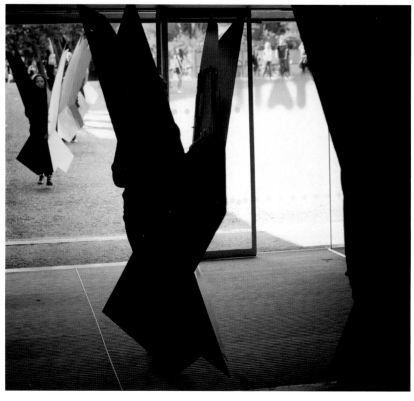

Symbols of Endurance

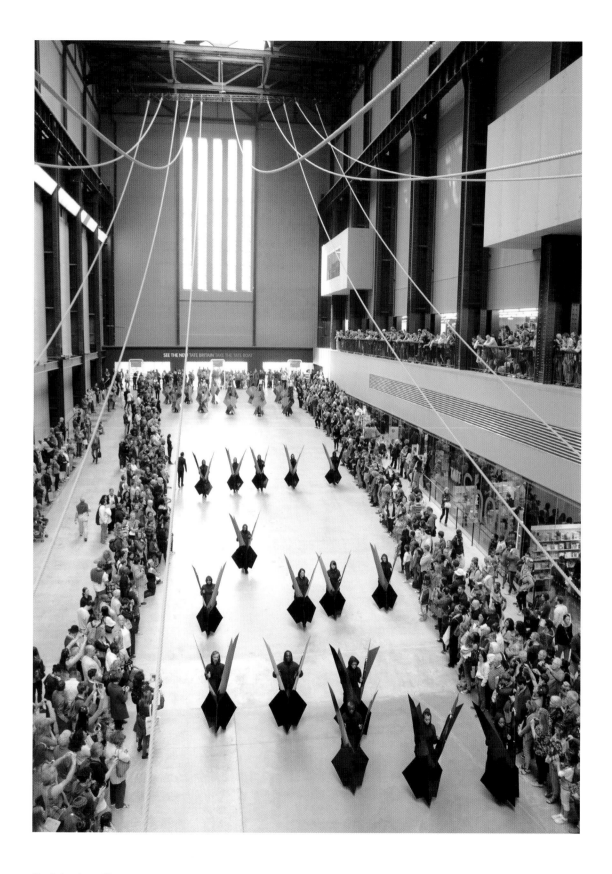

On Splendour: Elements of a Procession (for Marlon Griffith)

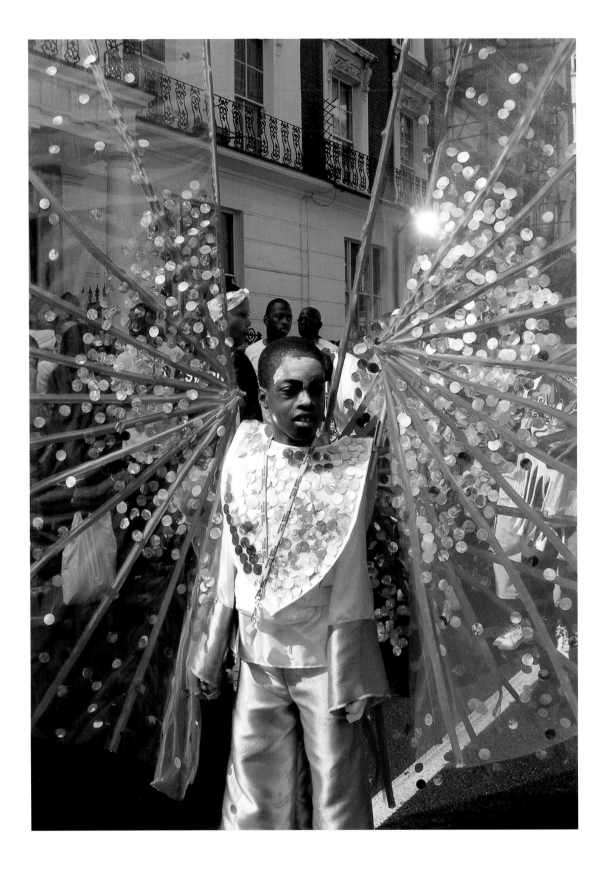

Tending
the Mercurial Dream

Chanzo Greenidge

Mas' as Resistance Movement

The architecture of Trinidad is a testament to its inequalities. Its built environment reflects a need to consume and discard the peoples who first inhabited the Americas, and the constant attempt to grab hold of the slippery concept of development. At several times during the year, especially at Carnival time, the true architectural genius of the people is entertained. Allowed to flow through the streets, it clashes and contrasts with more permanent, imported cousins, completing the idea of the battleground that is Caribbean design and architecture.

Born into the first generation of Trinidadians to be educated "in their own image", thanks to the indigenization movement that marked the 1970s, Marlon Griffith is enriching the traditional concept of mas' as resistance movement. However, his journey reflects the reality that artistic practice, like many other forms of creative expression, still does not fit readily into the logic of a space thoroughly remade and renamed through an imperial imagination. Caribbean societies, dually constrained by a lack of

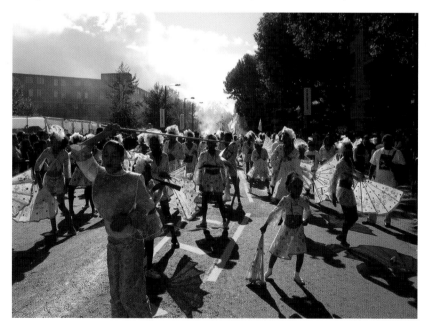

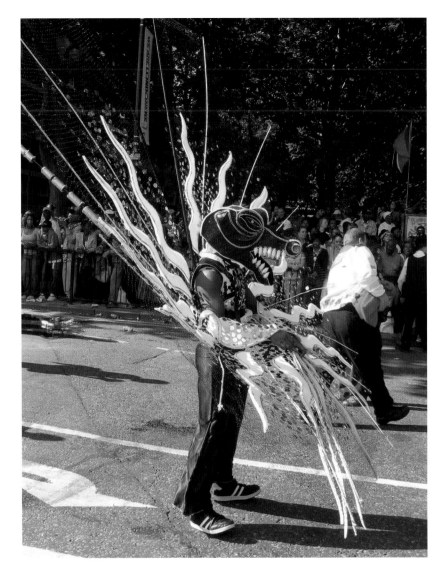

Left: *Dragon's Mouth*, 2006, Notting Hill, London, United Kingdom
Opposite: *Canboulay* concept sketches, 2000, graphite and white ink on brown paper

internal confidence in the face of thorny issues of social identity and relationships, and the imperative of attracting fickle tourism and investment dollars from outside the region, remain uncomfortable with the critical platforms presented by the artist.

However, as great talent often does, Marlon has found a way to turn margins into highways. He is transcending the squabbles of Caribbean society by offering it a new way to admire and express itself. In the absence of a strong institutional framework, the Caribbean artist must quickly learn the tricks of the entertainer or the politician, or else risk internal exile. Marlon provides a unique middle way to be true to his ideals as a creator of art. He does this by digging deeper into the cultural resources of the Caribbean, navigating courageously between media, and negotiating with a

new transnational generation of curators and researchers in the Global North.

Mas' has, unlike many other visual and performing arts, two audiences: the players who must usually be convinced to invest time, energy, and money into interpreting and embodying the character envisaged by the mas' architect; and the viewing/judging public who experiences the designer's strategic (mas' is often a competition) and artistic vision through the performance of the masquerader. Traditional mas' draws from African ritual dance in that it is an art of becoming. The mas' player must become the mas', must transform into the character, not just to make the audience believe, disbelieve, and then believe again but to do justice to the ideas of inversion, transformation, and catharsis that allow the (postcolonial) society to survive. Marlon is mining this traditional vein more deeply than most, challenging musicians, authors, performers, and masqueraders to come together to help realize his vision. An increasingly specialized cast thus become stakeholders in his vision, which he seems to renew year on year like a good calypsonian. This is the type of festive mentality that might be mistaken for a new global civilization in years to come.

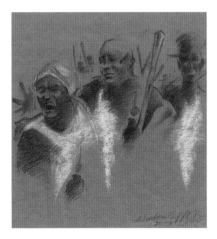

Mas' in Supernatural Multimedia

Left: *Bush Medicine: Ven-Venn* presentation sketch, 2004, Prismacolor on paper
Middle: *Bush Medicine: Jump up an kiss meh* presentation sketch, 2004, Prismacolor on paper
Right: *Bush Medicine: Bois Bande* presentation sketch, 2004, Prismacolor on paper
Opposite: *Ring of Fire* thumbnail sketches, 2005, ink on paper
p 44: *Blueprint: House of Hope*, 2007, Port of Spain, Trinidad
p 45: *Blueprint: House of Fire*, 2007, Port of Spain, Trinidad

Benefiting from an organic education in the Carnival arts as an apprentice at both the Trinity Carnival Foundation and Peter Minshall's Callaloo Company, Marlon returned the favour to his masquerader with early work that showed a storyteller's focus on teaching through experience. His first mas' band as a bandleader, *Bush Medicine*, 2004, gave its participants insight into the knowledge about traditional medicinal plants that is both revered and stigmatized by Caribbean society. This idea of embedding lessons and conversations in mas' is also visible in his 2007 Trinidad Carnival presentation, *Blueprint*. In this work, Marlon drew design elements from the gingerbread houses of colonial Port of Spain. The resulting costumes and their interplay with the built environment presented a complex Trinidadian society, as architect Colin Laird did so successfully in his work on Trinidad's iconic NALIS Building, creating a platform to conceive of a common past and an inclusive future.

Marlon balances the desire for technical perfection with the communicative power that every mas' player craves (known to many as "the experience"). The simplicity and economy of his Carnival costumes are deceptive, however, as Marlon's balancing act also relies on a third and less visible pillar: research. Deborah Bell notes that Marlon's work draws heavily on "mythical characters, zoomorphic animals, and energy forces".[1] Given his interest in the supernatural multimedia aspect of mas', his research into the presence of the animal in the art form of capoeira in preparation for *Ring of Fire* was no surprise. In capoeira, one must find one's own character, one's own animal, and be aware of what each movement demands in terms of

1 Bell, Deborah, *Mask Makers and Their Craft: An Illustrated Worldwide Study*, Jefferson, NC: McFarland & Company, 2010.

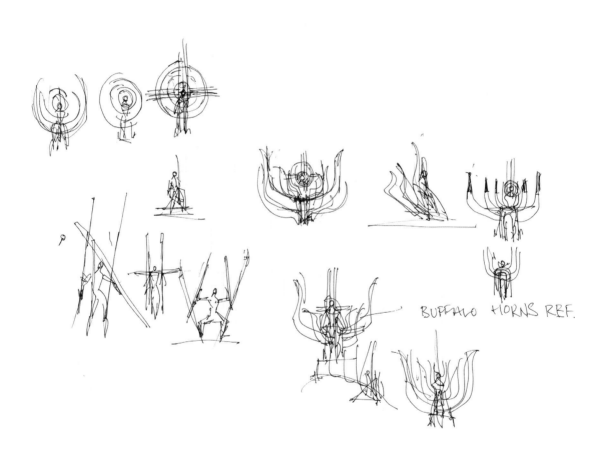

BUFFALO HORNS REF.

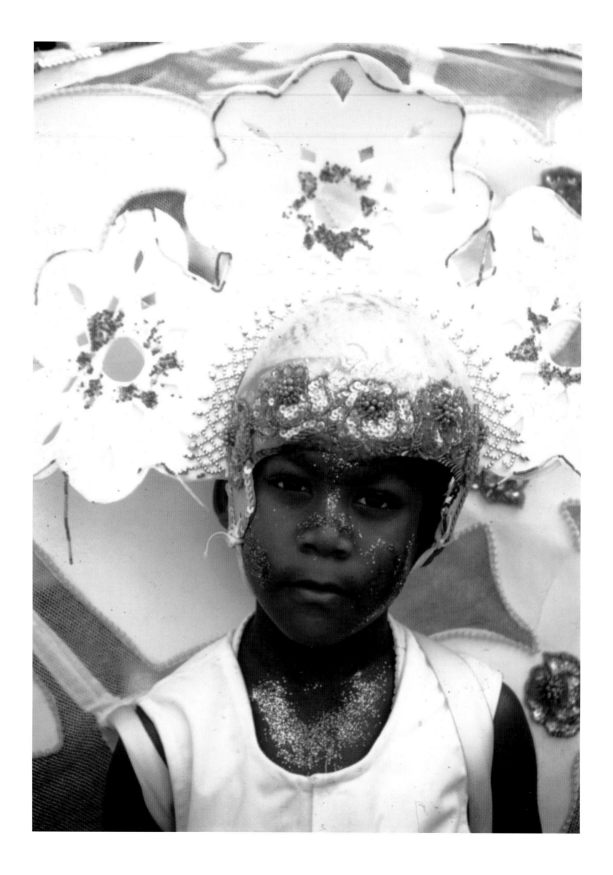

speed, space, and weight. With movements that carry names like *Vôo do gato* (Flight of the Cat), *Vôo do morcego* (Flight of the Bat), *Vôo do urso* (Flight of the Bear), and *Escorpião* (Scorpion), the player is called on to elicit an emotional reaction, even while improvising in response to rhythms, loaded messages in songs, and fellow players' physical and mental manoeuvres. In tracing our conversations on capoeira back to the final production of *Ring of Fire*, I saw that while his visual language is born out of his own creative imagination and interaction with other visual artists, he also depends on consistent and attentive interaction with primary and secondary sources. This adds to the social and symbolic power of each ingredient he is bringing into his process, from the quality and texture of the materials to the meanings behind his patterns.

It is remarkable that he does not "sell" himself as an expert on the Caribbean. In fact, he has continuously challenged his own understanding of the Caribbean, trying to learn more about the ghosts that live within its hybrid traditions. Marlon is also remarkable in that his appetite for artistic collaboration is matched by his ability to work efficiently and successfully with fellow artists and thinkers. A key example is his collaboration with Jaime Lee Loy and Nikolai Noel on the Collaborative Frog project, 2007–2009, a partnership forged out of Mario Lewis' seminal Galvanize project, 2006. Emblematic of the collaboration was the 2008 production *La Fantasie*, where they built a middle-class house of horrors which took aim at the secrets and sufferings that lie just beneath the surface of aspirational post-colonies.

In a Caribbean arts environment where trust, mentorship, and opportunities for exchange were scarce, Collaborative Frog was a step in the other direction. In this collaboration, three emerging artists gave each other the gift of a critical space that protected their right to work hard. A decade on, Marlon, like Bruno Latour's critic, is intentionally designing spaces for conversations for diverse actors around an honest confrontation with self and society. This communication process is at the centre of his understanding of art and the role of the artist. By building relationships that will outlive the artistic collaboration, he adds danger and promise to the social power of his creative presentations.

Top: *La Fantasie*, 2008, collaborative installation with Marlon Griffith, Jaime Lee Loy, and Nikolai Noel, Port of Spain, Trinidad
Bottom: *La Fantasie*, detail of Jaime Lee Loy's projected video, *Bruise*, 2008, Port of Spain, Trinidad

Symbols of Endurance

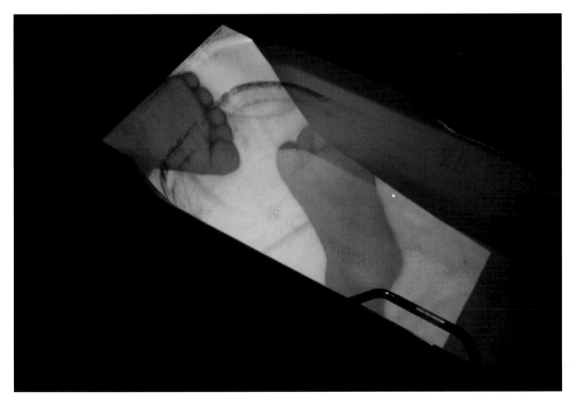

Rethinking Mas' as Cinema

Left: *POSITIONS+POWER*,
2014, Port of
Spain, Trinidad
Opposite: *The Ballad of
Francisco Bobadilla:
Soldier*, 2012, Port of
Spain, Trinidad

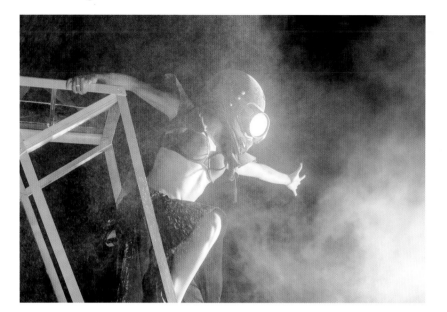

The Trinidadian cinema of the twentieth century, as Peter Ray Blood notes, was divided into sections: "pit, house, balcony—and one could discern the social standing of most patrons depending on which section they purchased a ticket for".[2] I draw parallels with a twenty-first-century mas' experience that features exclusive "all-inclusive" sections, and price ranges have created a niche of Carnival-specific loan products for local banks. In the midst of this, Marlon's 2014 *POSITIONS+POWER* presentation crosses over from his current home of Nagoya, Japan, emerging from the streets of his hometown of Belmont with a poignant, accusing question: "Whose Carnival Is This?"

Walking a tightrope between artistic elevation and gentrification that has eluded so many Afro-diasporic expressions, Marlon's work, which combines some of the most powerful aspects of traditional and contemporary mas' making, speaks to a wider role for mas' in the context of building community in the city.

This opportunity is being lost by diasporic mas' makers who focus on recreating home rather than creating new spaces of critical discourse in the North. It is also lost as mainstream mas' becomes more dependent on touristic clichés of redemption through nudity and social media-ready strategies of co-branding with lifestyle sellers and the use of celebrities to drive consumer interest in the mass production of mas'.

2 Blood, Peter Ray, "Cinemas of old: Gone but not forgotten", *Trinidad Guardian Online*, 21 August 2014.

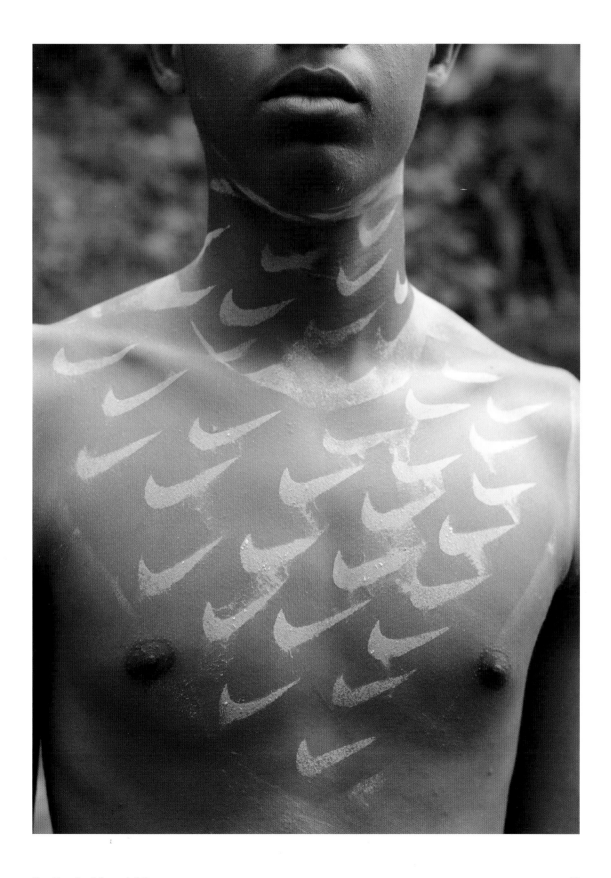

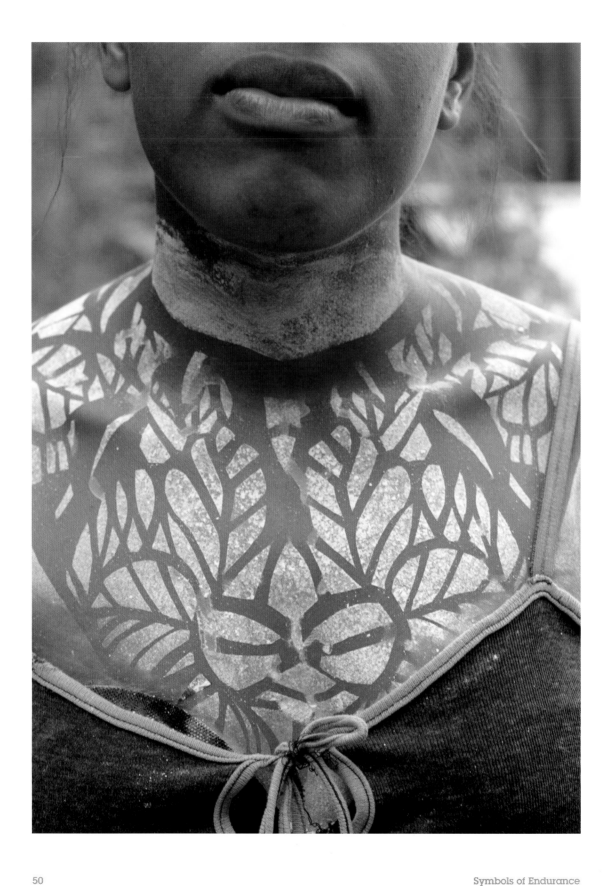

In this sense, he is not simply bridging postcolonial spaces, but his artmaking is allowing us to recognize that we are at a point of gentrified development in the "Aerosol Kingdoms", a collection of cities in the urbanizing Americas where clashes engendered by migration, inequality, technology, and cultural co-optation are playing out in patterns that would amaze even the graffiti calligraphers of 1980s New York City. The challenge of this moment is not only providing recognition and space for multicultural communities but also of building space for a dynamic community through the input of the visible majority. The alternative—disinterest and social degeneration due to the increasing social, ecological, and economic costs of exclusive affluence—is reflected in Nalo Hopkinson's moving dystopia on post-gentrification Toronto, *Brown Girl in the Ring*, 1998.

Marlon Griffith is representative of a long-standing trend of emigration among highly-skilled nationals from the Caribbean seemingly unable to find sustainable challenges, funding, and recognition in their countries of origin. One may ask what this means for the survival of the region, when the possibilities of ingenuity and civilization are still widely assumed to end at the borders of Europe and North America, which are supposedly better equipped to manage such lofty things, and which still play out the colony's role of exporting wealth in its raw form to places higher on the "Great Supply Chain of Being". One might ask whether this colonial bias, ingrained since the days of the triangular trade, has now come full circle in the form of the wholesale export of talent.

However, I believe Marlon's direction is different. And that difference is significant.

Marlon's work brings together various forms of knowledge, performance, and resistance movement forged through the African diaspora experience of exclusion and legal-social oppression. He has constantly mined this experience, an encyclopedia of survival strategies for creative responses, and his work speaks to the ability to adapt his own art to the real pressures of oppressive power, politics, and social structures. The unique contribution of Marlon's work is the strategic intent to reconcile the values of contestation that remain central to these diasporic expressions with life in the hesitant multiculturalism of the North.

His work and his method stand at the crossroads of fine art and the theatre of the oppressed. So there is the designer/director's vision and a passionate technical rendering of that vision by him as bandleader (producer/stage manager) to an increasingly specialized group of players and builders. But then there is the critical conversation. His concern with creative archiving and representation of his moving processions points to work that is evolving from participative event to immersive architecture. While many follow the colonial and neo-colonial path,

Marlon's is directed by a different compass: his own aesthetic and ethical statement of consistent, creative, and disciplined work. He is spreading a message and a way of dreaming the city, bringing his unique form of festival discipline to a world that desperately needs a different way to combine diversity and efficiency.

As the artistic becomes more everyday through the bleeding of fine art architecture into industrial design, the omnipresence of branding from T-shirts to tattoo art, and the increasing reliance of fashion on the disposable and the carnivalesque, the idea of well-oiled, revolutionary, communal fine art is right on time.

This page and opposite:
Symbiosis, 2006,
Kingston, Jamaica

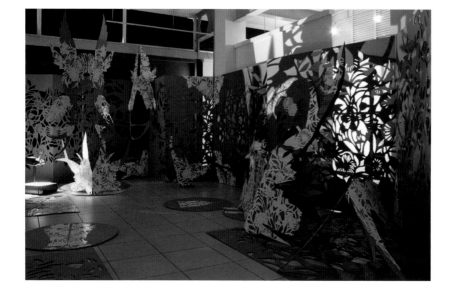

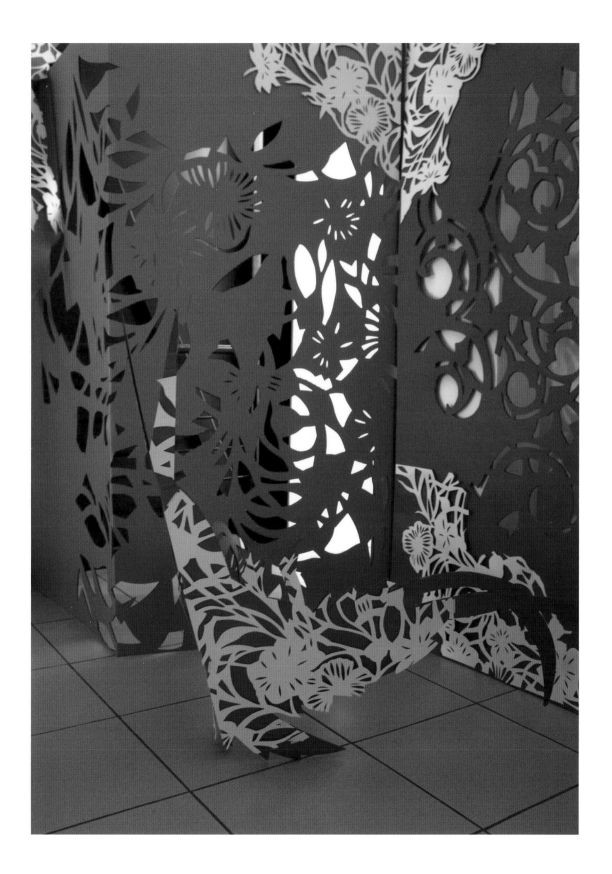

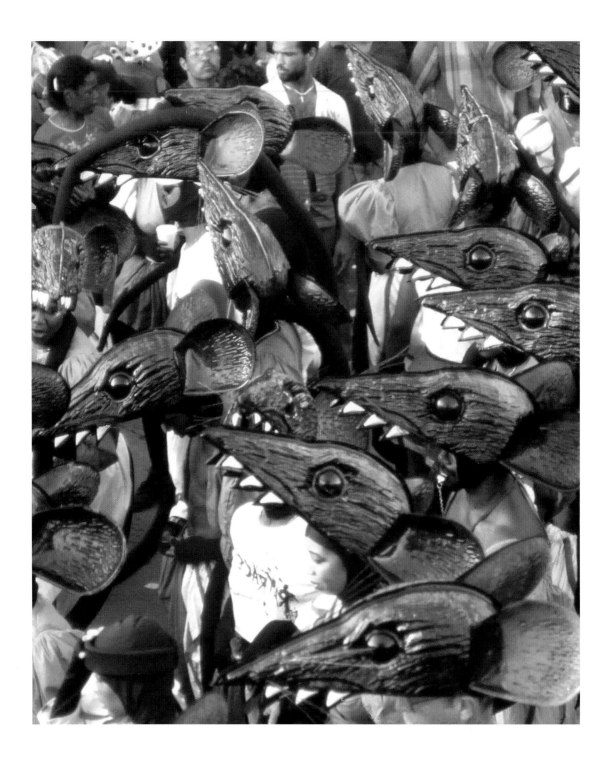

Peter Minshall,
Ratrace, 1986

Quickening the Heart: Marlon Griffith, Masman from Japan

Claire Tancons

A boy child comes out of Belmont at the corner of Cadiz Road or Jerningham Avenue, and faces the Savannah. He soon sees them, throngs of them, on Queen's Park East, racing like the plague. Ten years old, he frames the scene, or, rather, his eyes register thousands of frames in minutes. An outbreak of black with slithers of pink and coatings of grey. Rats! Black are the masks, pink the standards, and grey the costumes. Rats! They've come down the hills, out of the gutters, to run their yearly race. "Dey say he get horn." "For Truth?" "A Homo?" "Punch say".... The slogans that adorn the standards they bear have turned into a loud gossip. Their protest, if it is one, is a carnival. Their race is a rat race. *Ratrace*!

Almost three times ten years later, I look for cues of Marlon Griffith's witnessing of what he would later describe as the foundational event in the formation of his artistic vocation. Beyond his recollecting and my fictional narrating, there is a flurry of photographs online and I have folders full of TIFFs and JPEGs of Peter Minshall's *Ratrace* mas' performance in Port of Spain during Carnival 1986. The teeth I can see in the photographs are frightening; the ears, grotesque. The whole thing seems to come out of a comic book, speech bubbles and all. And the tails. So long they needed to be held up—and they were: under the arm like a clutch, in the hand like a whip, above the head... for what now? The shimmer of freshly moulded plastic conferred appeal to otherwise unseemly disguises. Something about it must have captured the ethos of the era. I mean, we'd just entered the second half of the 1980s and people wore that for Carnival: rat costumes!

It's been almost 30 years since Minshall's *Ratrace* sprawled through the streets of Port of Spain and almost ten years since Marlon's performances started to unfold before the world in so many displaced Savannahs. In 2008, in Gwangju, South Korea, the May 18 Democracy Square—in effect a large traffic island at the confluence of three major avenues—became one such Savannah, and the seventh Gwangju Biennale the first international arena in which he presented a mas'-

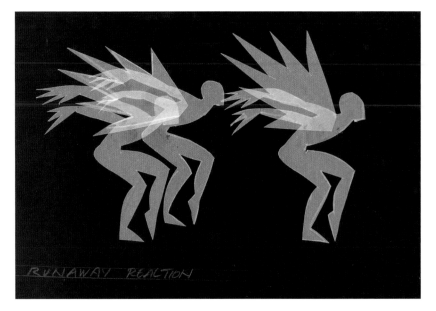

Left: *RUNAWAY/REACTION* concept collage, 2008, vellum and white pencil on black paper
Opposite: *RUNAWAY/REACTION* concept drawing, 2008, white pencil on black paper

inspired art performance.[1] Up until then, Marlon had kept his mas' making and artmaking activities separate, designing kiddies bands for Carnival on the one hand and making drawings and installations for exhibitions on the other. His artmaking practice was infused by mas' making techniques and themes and his mas' making designs were much touted for their distinct artistry.[2] Marlon was also invested in performance, though the first he did was on the smallest possible scale, his own body, and in Cape Town, far away from Port of Spain.

At an even farther geographical remove from Trinidad, and further into a conceptual leap forward toward an integrated artistic practice, Marlon created a potent precipitate as his contribution to SPRING in Gwangju. *RUNAWAY/REACTION*, whose title borrowed from the name of a chemical reaction, offered no king or queen, no jury prize, but it did offer a people's prize. Other photographs attest to the impact of Marlon's experiment in the early fall of 2008. The audience seems struck by surprise as SPRING sweeps through the streets. When *RUNAWAY/REACTION* rolled past, creatures of pure imagination

1 It was envisioned as such by Anthony "Sam" Mollineau, a member the Callaloo Company, Minshall's now defunct artistic workshop and production company, with whose project manager, Todd Gulick, I collaborated closely.

2 I have written about the impact of the teachings of the mas' camp onto Marlon's artistic formation in "Lighting the Shadow: Trinidad In and Out of Light", *Third Text*, vol 21, no 3, May 2007, pp 327–339. That essay took as a departure an eponymous exhibition at the now defunct Caribbean Contemporary Arts (CCA7) in which I first curated Marlon's work.

borrowed a futuristic disguise of projected abstractions of water and became moving human screens of spiked costumes. The rats are long gone. The images remain.

Enough already. All that old talk. Marlon is in Nagoya now and I am back in New Orleans. "He writes me from Japan. He writes me from Africa...." Halfway through *Sans Soleil*, 1983—or maybe closer towards the end, I can't recall—Chris Marker introduces the motif of Carnival as part of his fictional epistolary recollection and filmic retrocollection of castaway images. Carnival in Guinea-Bissau, not Trinidad, though roughly from the same period that Minshall's mas' awakened Marlon's artistic sensibility. As a backdrop, there are the independence struggles, though against the Portuguese, not the British. The role Carnival plays in national affirmation in the postcolonial period is better analyzed in—indeed is the centerpiece of—another, slightly earlier, landmark film essay, António Ole's *Carnaval da Vitória*, 1978, but I digress. Then, of course, yes, there is Japan, the other pole of the sunless world, where Marlon has been based since 2009.

Carnival, anti-colonial resistance, Trinidad, Japan, film, and travel: these are the coordinates of Marlon's artistic map, which *Sans Soleil* helps me navigate. In this essay, I want to talk about film and memory more so than mas' and performance, framing rather than making or playing mas'. These are related (of course?), but not in the way in which I had previously thought, and maybe not in the way in which he thinks about it at all. This text is very much an introspective conversation about artistic intention and curatorial projection, conflated with a non-exhaustive account of my ten-year collaboration with Marlon (2004–2014).[3]

"He writes me from Japan...." I do wonder whether Japan's "neighbourhood celebrations", the counterpoint to "the economic miracle" which belong in the list of "things that quicken the heart", provide a fertile ground from which to rethink Carnival, that other neighbourhood celebration (recall Belmont). I intend to ask him. *Sans*

3 Unless otherwise noted, I curated all the works mentioned in this essay:
• Lighting the Shadow: Trinidad In and Out of Light, CCA7, Port of Spain, Trinidad, 7 October–4 November 2004.
• *RUNAWAY/REACTION* in SPRING, Gwangju Biennale, Gwangju, South Korea, 5 September 2008.
• *A Walk Into the Night*, CAPE 09, Cape Town Biennial, Cape Town, South Africa, 2 May 2009.

• *POSITIONS+POWER*, Port of Spain, Trinidad, 4 March 2014, performed for EN MAS': Carnival and Performance Art of the Caribbean, Contemporary Arts Center New Orleans, 7 March–7 June 2015.
• *No Black in the Union Jack* in Up Hill Down Hall: An Indoor Carnival, BMW Tate Live Series, Tate Modern, 23 August 2014.

Soleil seems to suggest that link. Sandor Krasna, the film's fictitious cameraman/narrator and stand-in for director Chris Marker, writes that "things that quicken the heart" are "not a bad criterion... when filming". Did it quicken Marlon's child heart to see grown up man-rats sprawl out of his neighbourhood in celebration of Carnival? My recollection of his account of the event registers like a still image, a framed scene, a film still: a fact further reinforced by the photographic frame through which I am now examining *Ratrace*. But this projection all goes back to one of his very first aspirations.

Marlon's exhibition Symbols of Endurance, curated by Emelie Chhangur for the Art Gallery at York University, brings abundant evidence of the way in which Marlon framed *Ring of Fire*, and previous processional performances, in a quasi-filmic fashion. Sequence after sequence, storyboards which are on display here for the first time, have always been central in Marlon's drafting process to show how he intends the performance to unfold processionally. Now, to be clear, at the time of the first experiment of SPRING neither Marlon nor I referred to the work he did as an artist nor the work I did as a curator as "processional performance". The term I began using circa 2007 was "procession", which I began envisioning as the possibility of curating public performance on a mass scale and for a large audience. Work included under this term might have initially come from a Carnival background but the concept could also embrace any contemporary artistic production.[4] "Processional performance" is the expression I have been using since 2014 or thereabout, and turns out to be well suited to Marlon's brand of mas'-inspired large-scale public performance, as well as providing further insights into the relationship between mas' making and filmmaking in this work.

This relationship between mas' and film is one that begs further investigation generally, in which I cannot indulge at length within the context of this text. What I can share is of general knowledge (among Trinidad Carnival buffs, that is): in the 50s and 60s, masmen used film as a resource for selecting subject matter and as reference for making

4 MAS': From Process to Procession, Caribbean Carnival as Art Practice, the title of an exhibition I curated for BRIC's Rotunda Gallery at Isolde Brielmaier's invitation in 2007, attests to that breakthrough. It was to include a procession in the immediate vicinity of the Gallery in Brooklyn Heights, but this aspect unfortunately never panned out.

costumes. Mas' bands of Roman centurions had the pepla qualities of Cinecittà cinematographic productions of the same period, while Fancy Indians donned feathers as fake as those of Hollywood Westerns. The most important, indeed foundational, relationship between film and mas', however, is not referential but structural, corroborated by the history of film or, as it were, the motion picture itself. From the Lumière brothers' very first film (*Workers Leaving the Lumière Factory*, 1895) to Georges Méliès' later cinematographic experiments (including *The Mardi Gras Procession* and *Mid-Lent Procession in Paris*, both 1897, to Jean-Luc Godard's "processional" filmic device (*défilement*), film pioneers and film avant-gardists have turned to actual processions to record images of bodies in motion and used the processional mode to set images into motion.[5] For the former, organic opportunities were still amply available in the waning popular culture of late-nineteenth-century Paris through funeral processions, military parades, and Mardi Gras parades, while for the latter they had to be reconstructed specifically for the camera.

Against this backdrop, Marlon's work appears proto-cinematographic. Marlon is concerned with two facets of the great experiment with images that led to filmmaking: the moving image on the one hand, and the projected image on the other hand. As concerns the moving image, Marlon, as evidenced in his use of storyboarding, does not so much look back to film for thematic references for making mas', as earlier masmen did, as he frames his mas'-inspired processional performances like film—akin to earlier filmmakers recording processional movement to highlight the technical capabilities of cinematographic machines. The relationship between projection and procession was not lost on William Kentridge whose early projection experiments and processional imagery date back to the late 1980s and early 1990s and are worth contrasting with Marlon's own experiments. Where Kentridge began with projections by way of drawing animation to figure processions only to arrive at processional performance over two decades later, Marlon furthered his interest in both projection and the performance of procession at the same time, with an emphasis on the latter.[6]

5 Blümlinger, Christa, "Procession and Projection: Notes on a Figure in the Work of Jean-Luc Godard", *For Ever Godard*, Michael Temple, James S Williams and Michael Witt eds, London: Black Dog Publishing, 2004, pp 178–187.

6 For an in-depth analysis of the processional trope within Kentridge's work see Leora Maltz-Leca, "Process/ Procession: William Kentridge and the Process of Change", *Art Bulletin*, vol 95, no 1, March 2013, pp 139–165. Kentridge's first live processional performance on record occurred as part of the unveiling of *Triumphs and Laments*, a monumental mural commission from Tevereterno in Rome on 21 April 2016.

As concerns the projected image, Marlon made his first experiment with projection with only the flimsiest of images: the cast shadow—where a solid object intercepts light between its source and the surface onto which it is thrown. In his installation for Lighting the Shadow: Trinidad In and Out of Light (CCA7, Port of Spain, Trinidad, 2004), the objects that acted as the intercessors for the images to be projected were five plastic "prints" made with the vacuum-forming technique used in mas' making—for moulding the *Ratrace* masks, for example. The light source was light bulbs precariously anchored to the ground with hand-made contraptions. The surface was the white walls of the gallery space. The figures, including the artist himself in a self-portrait, formed barely visible reminiscences of human forms emerging out of darkness as in *J'ouvert*, the nocturnal mud masquerade and cleansing ritual that inaugurates the two days of Carnival revelry in Trinidad.[7]

Marlon replicated this technique, this time adding motion, for his second processional performance, *A Walk Into the Night*, CAPE 09, 2009, which took place in the Company Gardens, downtown Cape Town. Where lights fastened to the ground projected shadows onto immobile walls in Lighting the Shadow, in *A Walk Into the Night* the whole projecting apparatus itself was set in motion. One hundred or so masqueraders, many coming from Cape Town's own carnival groups, doubled up as shadows projected onto moving screens. Kentridge's *Shadow Procession,* 1999, a stop-motion animation of torn black paper puppets walking in profile with a heavy burden, comes to mind. This "procession of the dispossessed" is particularly resonant within the context of post-apartheid South Africa out of which Kentridge's drawing animation work emerges and to which Marlon's nocturnal walk brings further fugitive figurations.[8] Marching three abreast, the line closest to the audience held white fabric screens aloft while those furthest away carried hand-held torchlights so that an abstracted likeness of the middle line was projected, as shadows, onto the other side of the screens. Fittingly, for a piece whose title referenced the almost eponymous anti-apartheid novel *A Walk in the Night*, 1962, by Alex La Guma, shadows were here used as a means to eschew the

7 For more on the making of this work and the exhibition in which it was featured see Tancons, "Lighting the Shadow", pp 331–332.

8 Cameron, Dan, "Procession of the Dispossessed", *William Kentridge*, London: Phaidon, 1999, pp 36–81.

Below: *A Walk Into the Night: Fire* comprehensive concept collage, 2009, vellum and pencil on black paper
Opposite: *A Walk Into the Night: Deer* concept collage, 2009, vellum and pencil on black paper

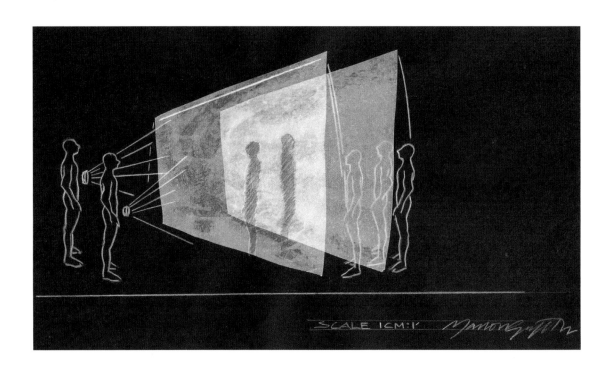

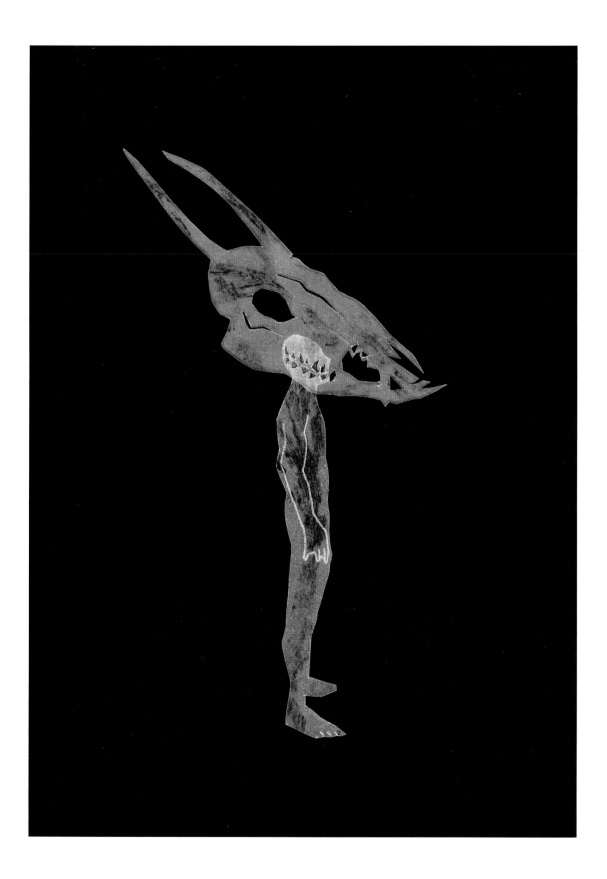

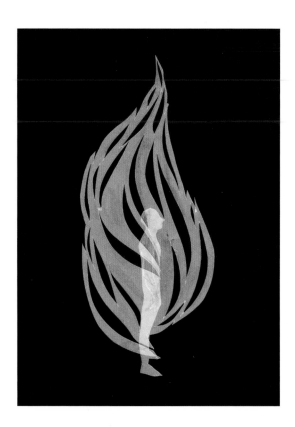

Top left: *A Walk Into the Night: Fire* concept collage, 2009, vellum and pencil on black paper
Bottom left: *A Walk Into the Night: Lady* concept collage, 2009, vellum and pencil on black paper
Opposite top: *A Walk Into the Night: Doberman* concept collage, 2009, vellum and pencil on black paper
Opposite bottom: *A Walk Into the Night: Dark Rider* concept collage, 2009, vellum and pencil on black paper
pp 66–67: *A Walk Into the Night*, 2009, Cape Town, South Africa

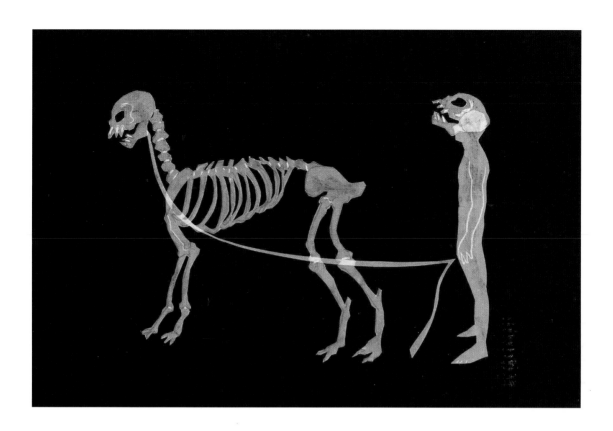

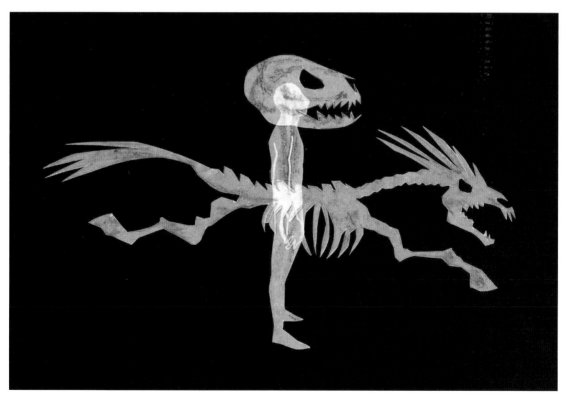

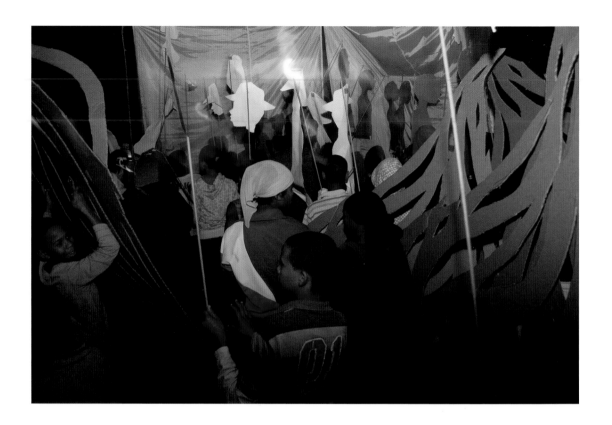

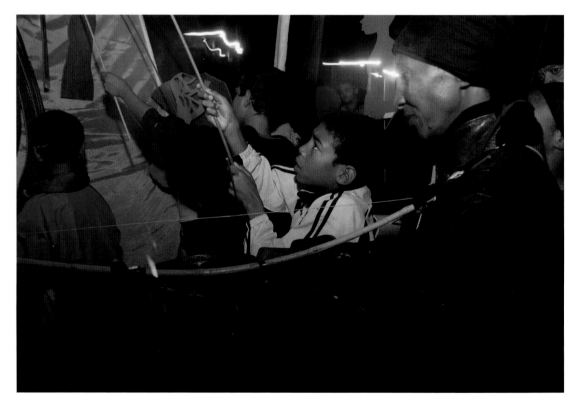

Symbols of Endurance

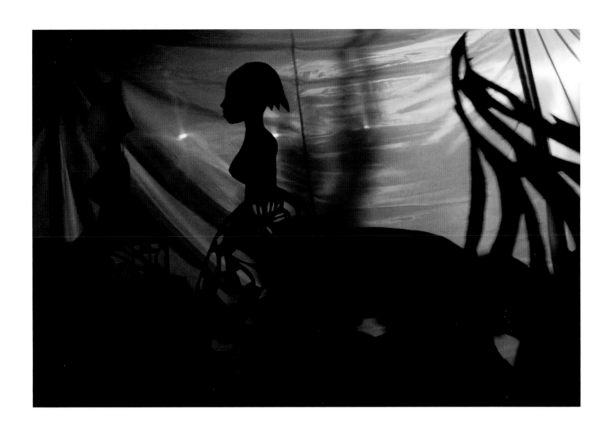

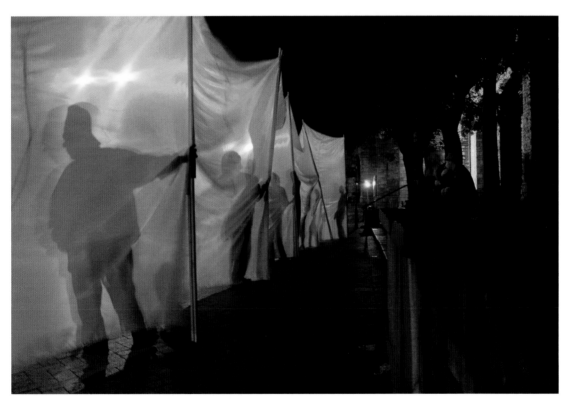

pitfalls of racial identification with skin color. "Holes in light", as they were once called, shadows provide a representational gap to rescue the image from oversignification, the body from hyperidentification.

Marlon's later experimentations with the projected image no longer involved shadows but rather light itself. For *RUNAWAY/REACTION*, a bluish hue unevenly highlighted fragments of costumes. Stemming from images of trembling water, alluded to in the title borrowed from the name of a chemical reaction, the projection turned the masqueraders themselves into ambulatory screens and turned Marlon, who walked backward with a hand-held projector during the entire 90-minute span of the performance, into the projecting apparatus. Light became the primary character in *POSITIONS+POWER* (in EN MAS', Port of Spain, 2014). Casting two beams of light from helmet-mounted flashlights, the "Overseer" opened a path out of the darkness for a small group of masqueraders while the "Watchdog", seated at the bottom of the surveillance tower on which the "Overseer" stood, featured a mouthful of human-teeth-as-seeing-eyes thanks to a mini-projector hidden in the visor of his helmet.

In both nocturnal processional performances, *RUNAWAY/REACTION* and *POSITIONS+POWER*, the projecting apparatus is used as a functional instrument for lighting. In *RUNAWAY/REACTION*, the abstracted meaning of the projected image—the overflow of substances under pressure—brought about a symbolic re-enactment of the emancipatory impulses

Below: RUNAWAY/ REACTION concept drawing, 2008, white pencil on black paper
Opposite: *RUNAWAY/ REACTION, 2008, Gwangju, South Korea*

Symbols of Endurance

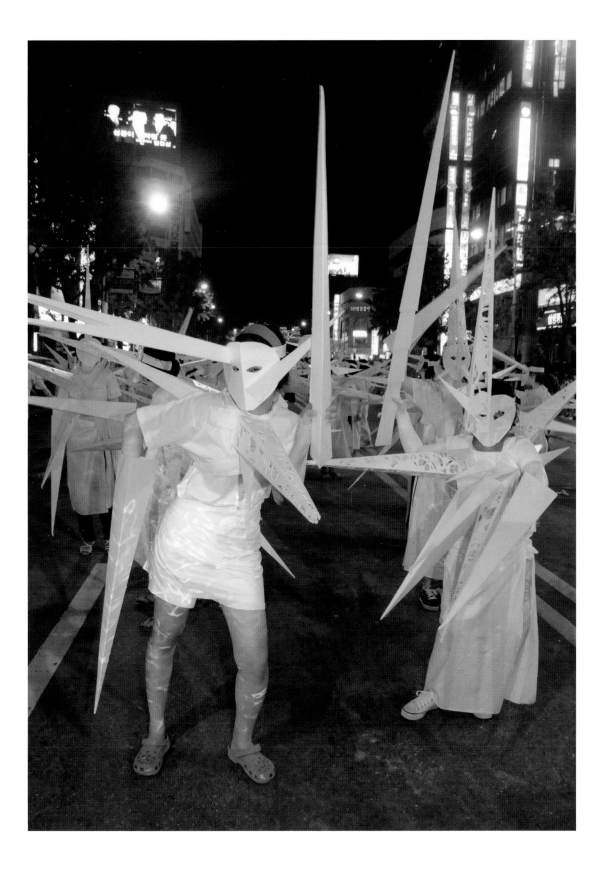

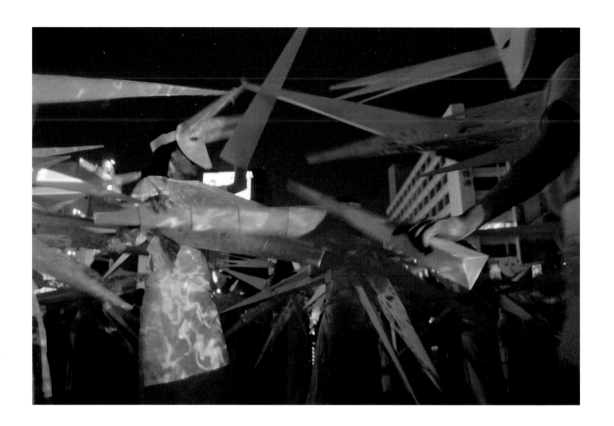

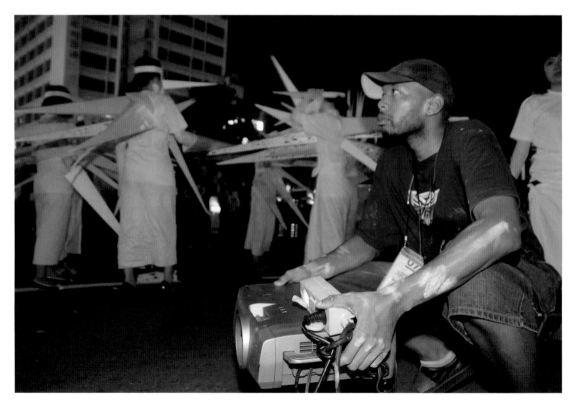

Symbols of Endurance

Above:

POSITIONS+POWER:
Overseer, 2014, Port of
Spain, Trinidad

Opposite top:

POSITIONS+POWER:
Doberman

Opposite bottom:

POSITIONS+POWER:
Overseer

p 72 top and p 73:

POSITIONS+POWER:
Doberman, 2014, Port of
Spain, Trinidad

p 72 bottom:

POSITIONS+POWER:
Overseer, 2014, Port of
Spain, Trinidad

of the formerly enslaved and colonized, specifically as they manifested in the post-abolition, pro-Carnival Canboulay Riots of Trinidad (1881 and 1884), and continued to manifest in Carnival through to Independence. In *POSITIONS+POWER*, the "Overseer" and "Watchdog" duo imply a continuum between the repressive colonial policing of the old and the police state and surveillance society of the new. If Marlon's referential titles provide cues to possible meanings of his works, it is the economy of light among the constituent parts of each work, whether turned inward onto the masqueraders as in Cape Town and Gwangju or outward at the crowd as in Port of Spain or London, that enables the processional performances.

What if, then, in simultaneously highlighting and disembodying the performance participants as spectres, Marlon's lighting apparatus proposes a reordering of the lived and perceived experience of the performance? Though often thought of as participatory, might the use of the body as a moving surface onto or from which to project light diffract the attention away from the embodied dimension of performance? Might the nocturnal performances discussed in this text function as dark chambers within which light is captured to be later released, primarily into filmic and photographic memory? How might mas' function within a diffracted global space in which participants are no longer neighbours invested in the year-long elaboration of their festivals but rather volunteers culled from workshops and enlisted for the performance? If the use of projected light and its ensuing disembodying effect function as a necessary disembodiment of a performance that is no longer localized within particular bodies, then Marlon's most enlightening contribution might come from answering this fundamental question: how to be a masman from Japan?

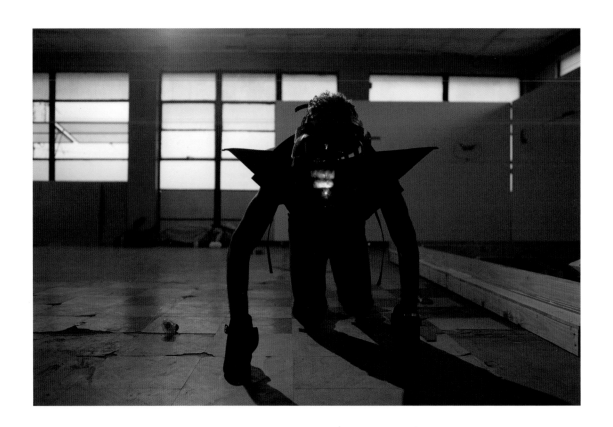

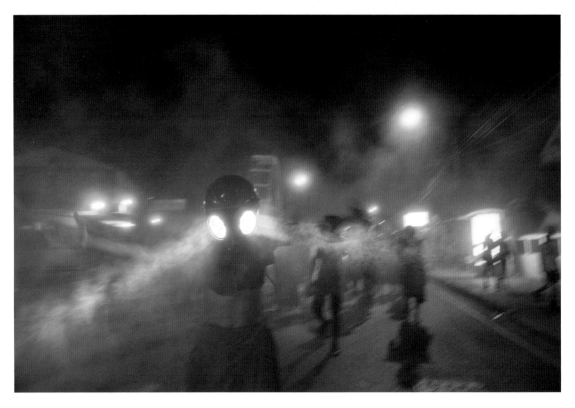

Symbols of Endurance

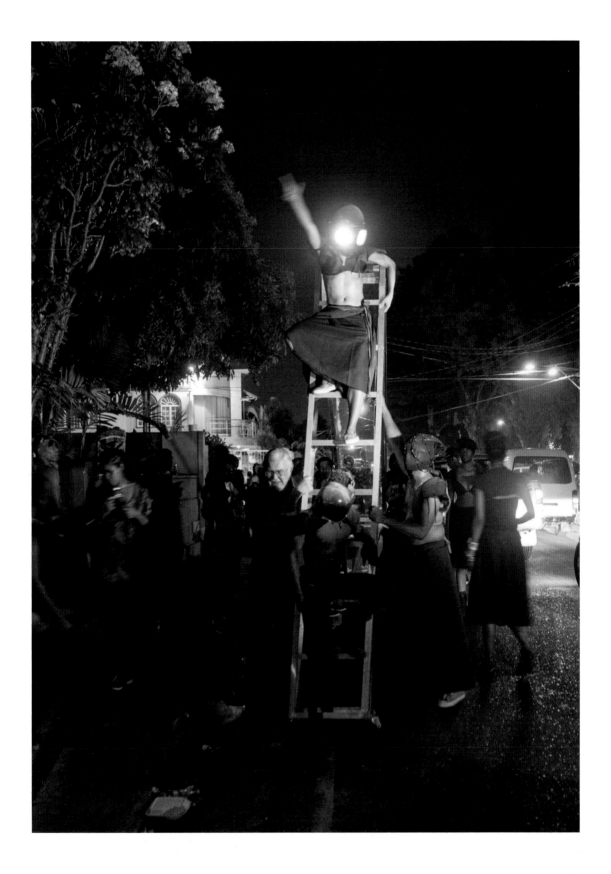

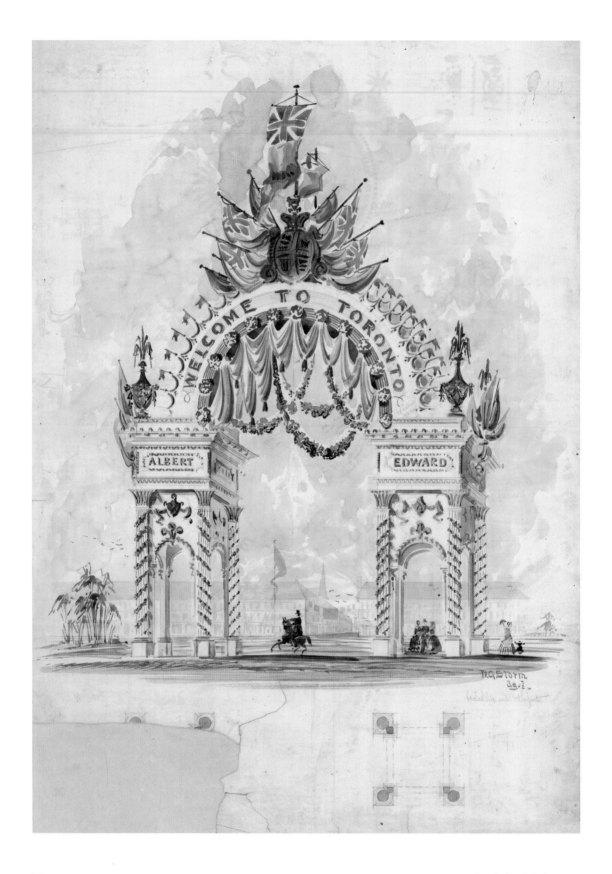

Watercolour rendering of triumphal arch designed for Toronto's reception of the Prince of Wales in 1860 by William Storm, C11-693-0-1, (641) 12, Archives of Ontario

Paving it Forth

Emelie Chhangur

[It was] the most magnificent spectacle I have ever seen. As an artistic effect it cannot easily be excelled, but as a popular demonstration I never witnessed its equal....

—Duke of Newcastle, 1860, on Toronto's grand procession to welcome the Prince of Wales

What is found at the historical beginning of things is not the inviolable identity of their origin; it is the dissension of other things. It is disparity.

—Foucault, *Nietzsche, Genealogy, History*

Paving it Forth

The place: Queen's Park Ontario Legislative Building, Toronto

The time: Too late, or at least an hour later than it should be… and counting

The scene: Chaos

The score: *Ring of Fire*, A Procession by Marlon Griffith

Opposite: Organizing the procession bands for *Ring of Fire* on the grounds of Queen's Park Ontario Legislative Building, Toronto, 9 August 2015

Loudly over a megaphone: "If you are wisdom, you are white and gold; if you are courage, you are black and gold; if you are respect, you are blue and red; if you are honesty you are blue and white; if you are truth, you are yellow and red; if you are humility you are white and [pause] the natural background…."

Two years of preparation is distilled into the mounting pressure of this penultimate moment: in between the marshalling and marching of a procession about to embark. Colour moves and marks position. Minutes seem like years. Time has come full circle. *Pave Forth!* [1]

1 "Paving it forth" was an expression that Toronto spoken word poet Moose (from Jane-Finch, a neighbourhood in Toronto) used to describe his role as a junior poet in the year-long spoken word mentorship program that spanned three of Toronto's "underserviced" neighbourhoods leading up to *Ring of Fire*. "Paving it forth" is a play on "paying it forward", which is an expression that describes the way in which a beneficiary of a good deed repays it onward to others, not back to the original benefactor—a centrifugal patterning of sorts. Paving, of course, is related to the street but rather than a uniform covering—as in paving a road—in this context, to "pave forth" should be understood as the preparations for an event, clearing the way for something else to happen, or laying the foundation, doing the "ground work". Interestingly, Victor Turner considered performance in relation to the Old French word *parfournir* meaning to "furnish forth" or "carry out thoroughly" as in "the proper finale of experience" (*From Ritual to Theatre*, New York: PAJ Publications, 1982, p 13). Paving forth is thus a furnishing *and a furthering*, an open dramaturgy of transposition and transformation conferred upon performative forms through the "it" of experience. Paving forth lays the foundation while re(con)figuring the ground.

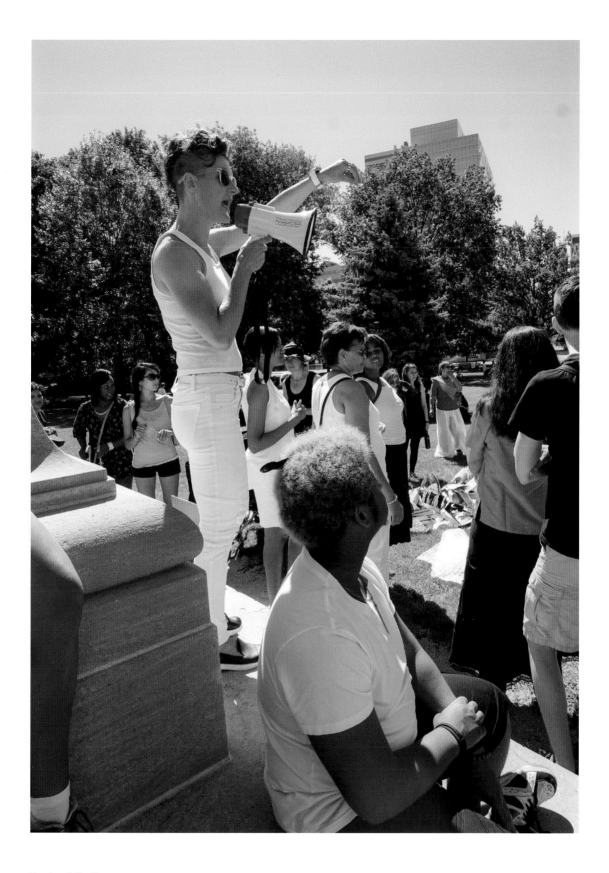

Suddenly, as if by magic, we assemble together, band by band: a living line loosely led by the order of Wisdom, Courage, Respect, Truth, Honesty, Humility, and Love—the Anishinaabe Seven Grandfather Teachings—and the respective colours that reflect and project the virtues these words symbolize: a collective of 300 Torontonians mnemonically inhabiting these teachings through costume, rhythm, movement, and spoken word. We depart the grounds of Queen's Park in silence. This is it. Here we go. The drumming begins. And oration follows:

> You can't judge people based solely on what you see,
> Just like how you can't judge a tree just because it sheds its leaves.
> Time comes and time goes, snow melts and flowers grow
> Everything is going to change but you always have what you know
> A system of wisdom resides in your mind
> So listen and you'll be surprised what you find [2]

Now on the street, the pavement seems soft. It makes like it's malleable. We feel like we're floating. Moving forward along University Avenue on 9 August 2015, through the heart of downtown Toronto, we dance across time, tripping on the toes of so many protagonists of Toronto's past: moving past equestrian statues and marble steps, under the tall trees, and along routes already marked by Toronto's Anglo-Saxon promenades subsequently carved out by Carnival revellers of Toronto's Caribana. Right past. Perched atop our shadows in the high noon of the sun, we follow in each other's path, "paving it forth", en route to Toronto's City Hall.

Top: Wisdom Orator Moose performing during *Ring of Fire* procession
Bottom: Anna Wren signing the poem "Wisdom" during *Ring of Fire* procession
Opposite top: Wisdom Sentinel Duke Redbird with artist Marlon Griffith and members of the Wisdom Entourage
Opposite bottom: Wisdom Entourage from *Ring of Fire* procession
pp 80–81: Courage Sentinel Mark Brose and Orator Burma followed by Entourage
pp 82–83: *Ring of Fire* procession, 9 August 2015, University Avenue, Toronto

2 This is an excerpt from the spoken word poem "Wisdom" by Moose. The poem was performed at Queen's Park just before we began the procession. Along the route, we stopped for six other spoken word poems written for each teaching, ending with an eighth written by Kareem Bennett, also from Jane-Finch, who played "Moon" in the procession. Moon's poem encapsulated all of the teachings and was performed after our culminating performance at Toronto's City Hall. Each spoken word poem was performed over a megaphone and simultaneously signed by a Deaf/HOH youth. Anna Wren signed "Wisdom" and Hope Rehman "Moon".

Symbols of Endurance

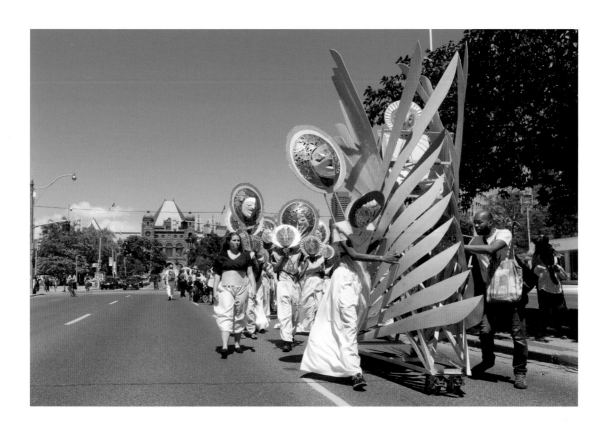

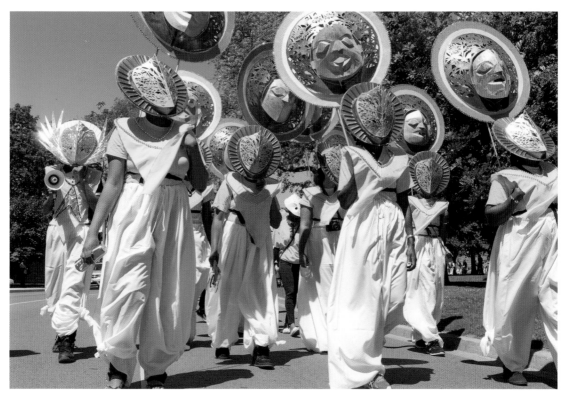

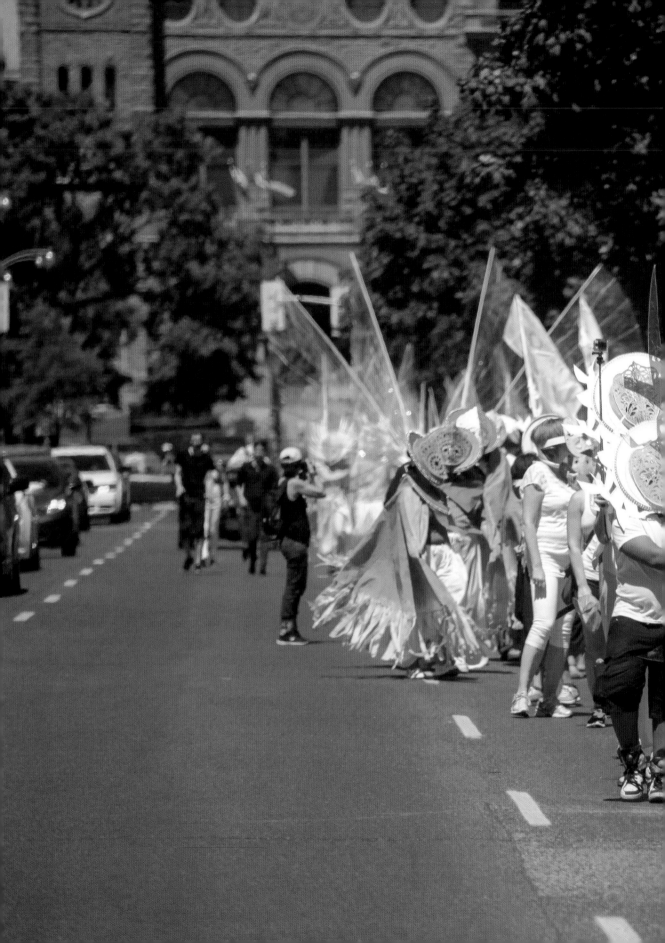

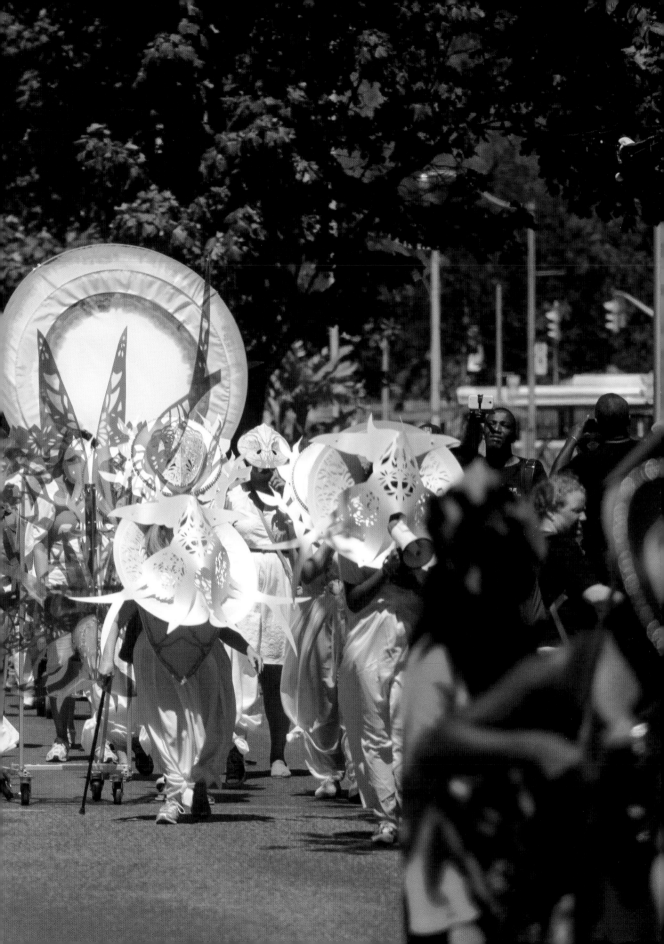

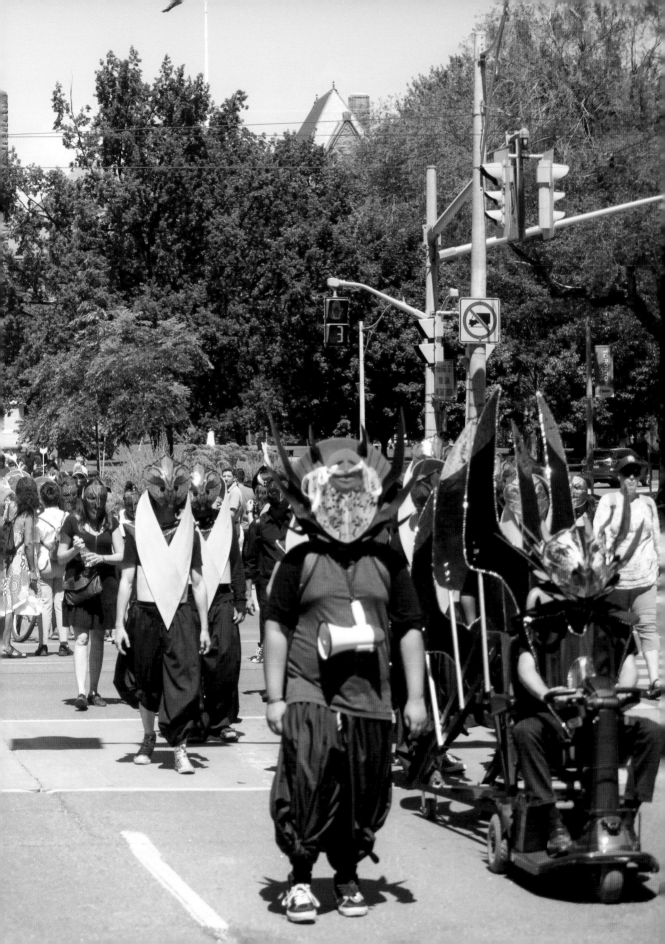

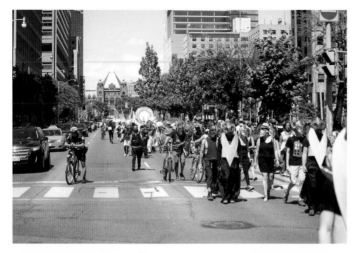

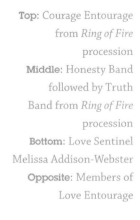

Top: Courage Entourage from *Ring of Fire* procession
Middle: Honesty Band followed by Truth Band from *Ring of Fire* procession
Bottom: Love Sentinel Melissa Addison-Webster
Opposite: Members of Love Entourage

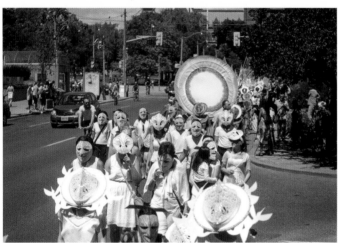

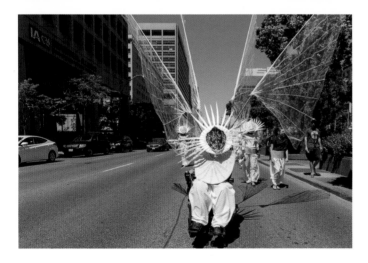

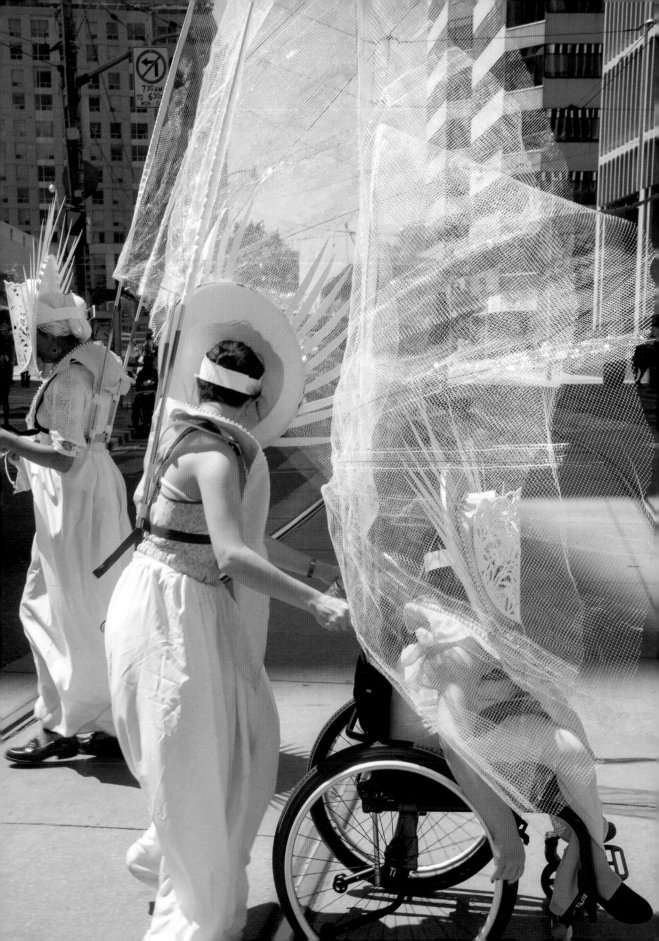

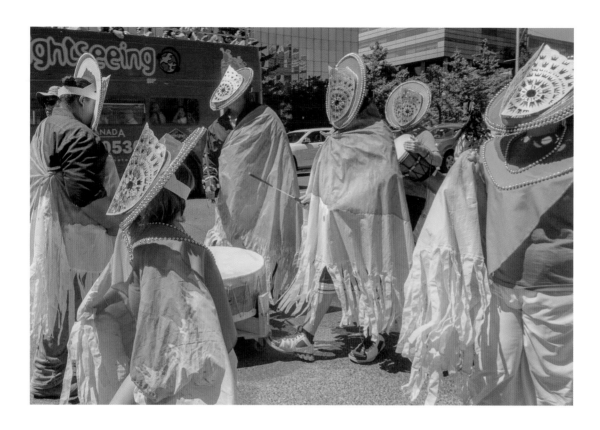

Above: Members of
Truth Entourage
Below left: Honesty Orator
Aliyah [Suviana] Burey
performing during *Ring of
Fire* procession with ASL
Signer Jennifer Lees
Below right: *Ring of Fire*
procession, 9 August 2015,
University Avenue, Toronto

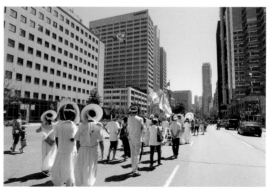

Symbols of Endurance

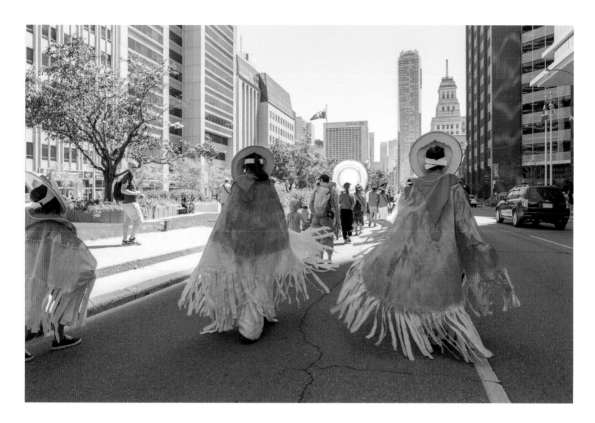

Above: Members of
Truth Entourage
Below left: Humility
Sentinel Torrance Ho and
members of Entourage
Below right: Love
Sentinel and Orator
Destiny Henry with ASL
Signer Cassie Rehman
pp 88–89: Truth Sentinel
Cathy Jamieson

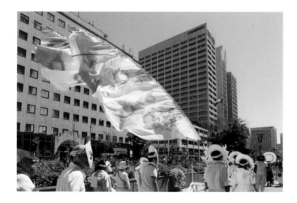

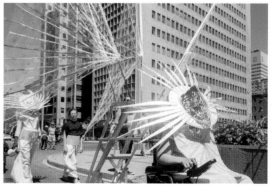

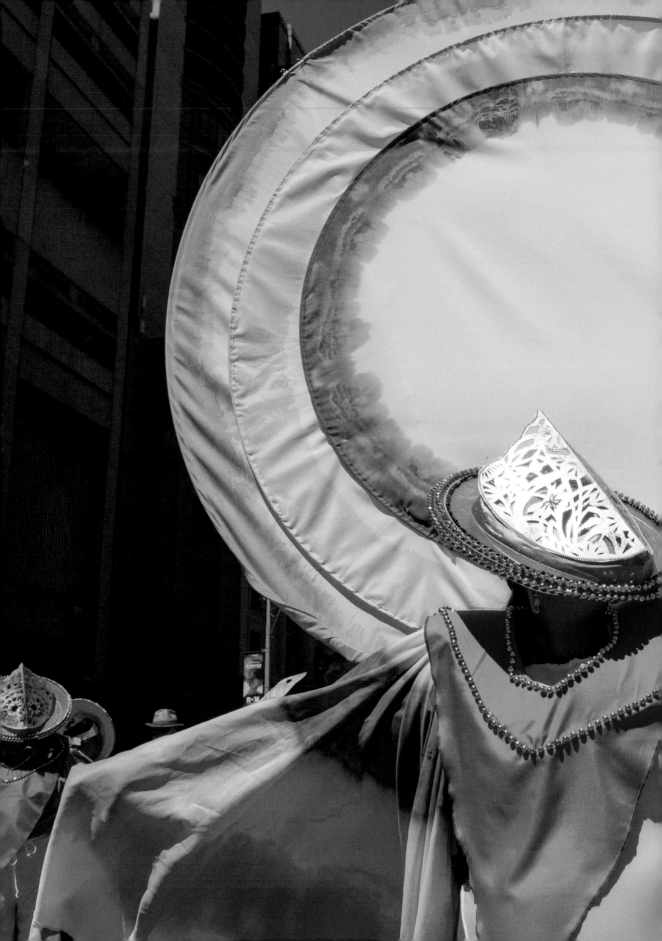

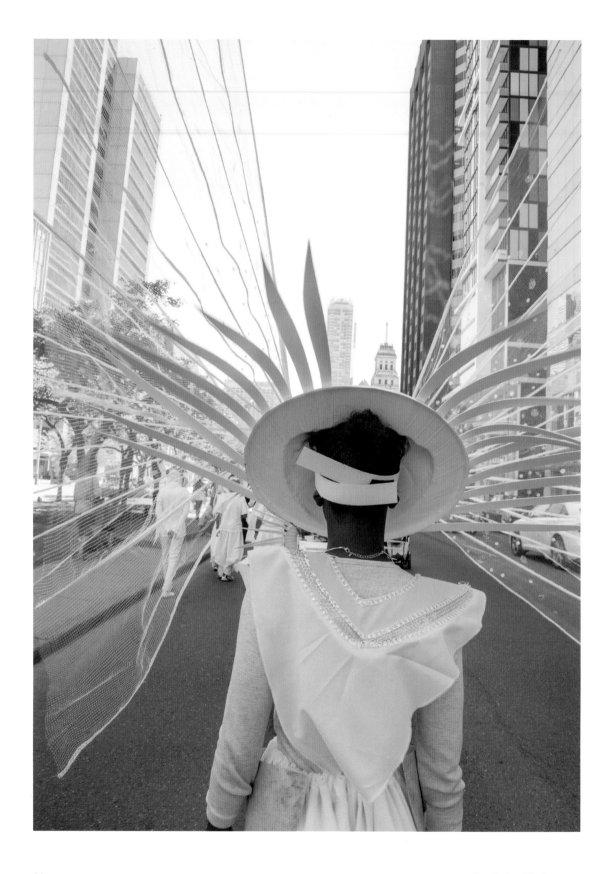

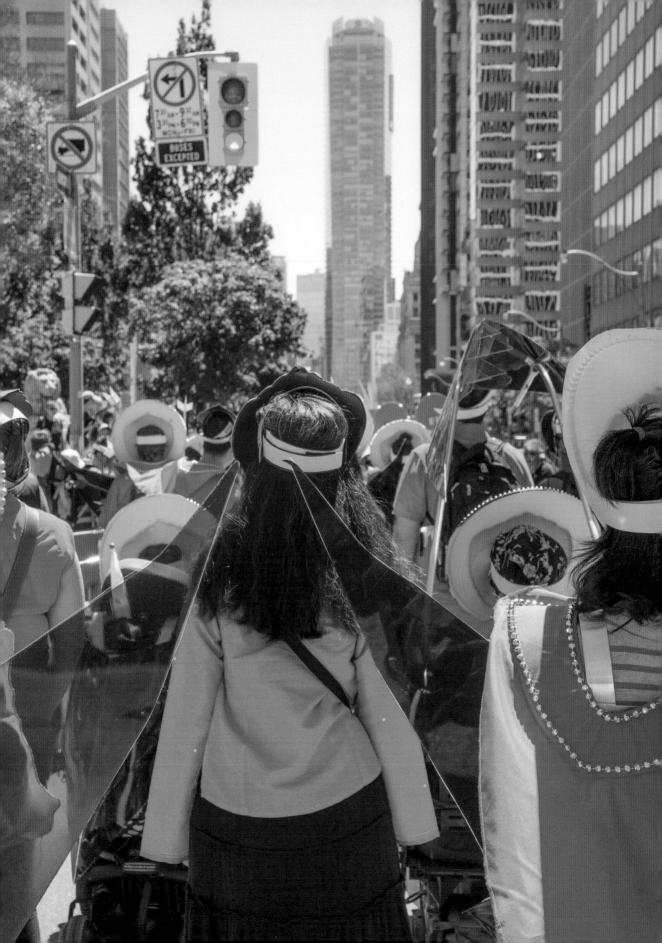

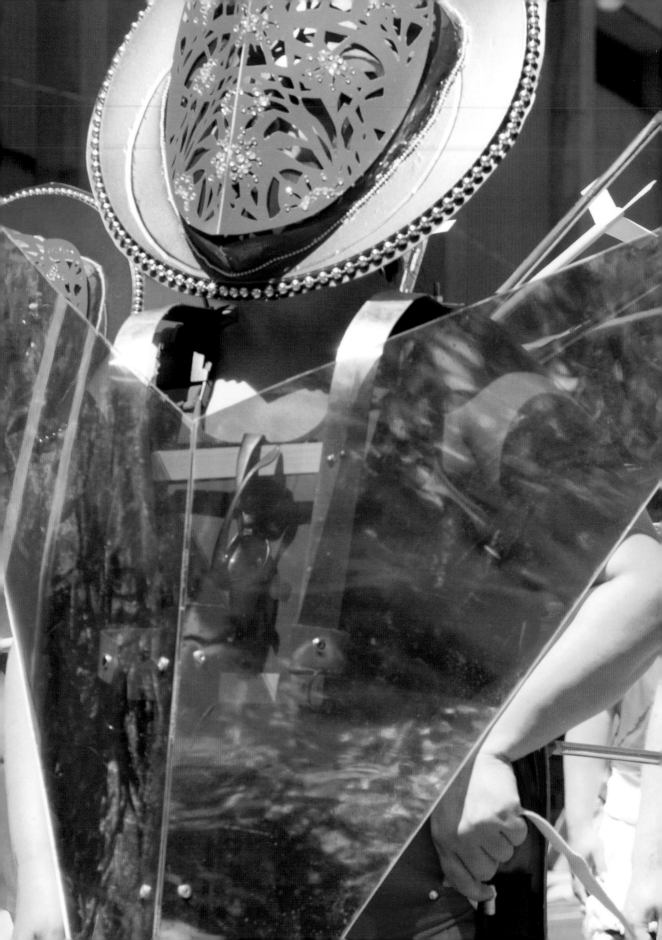

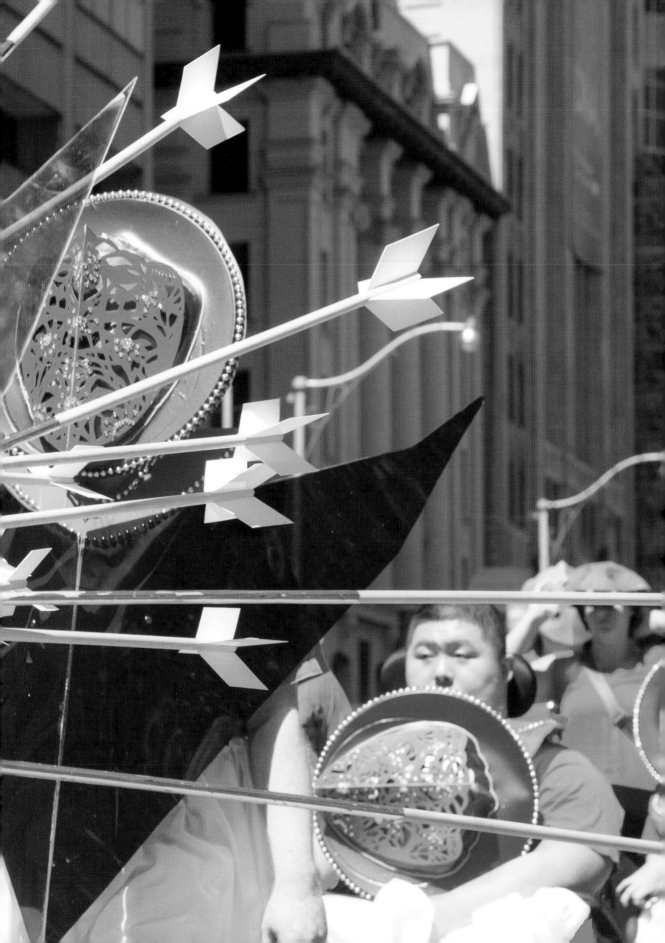

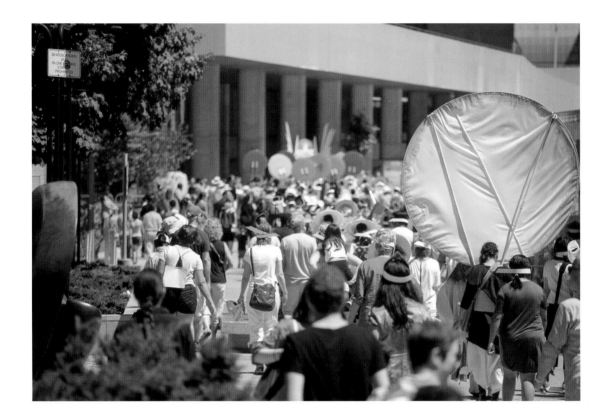

Symbols of Endurance

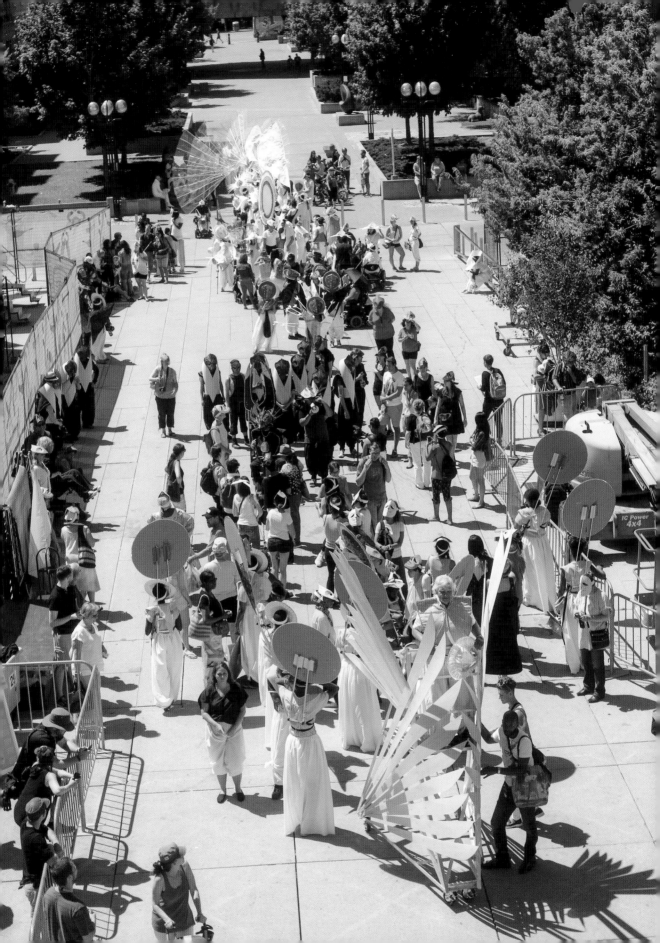

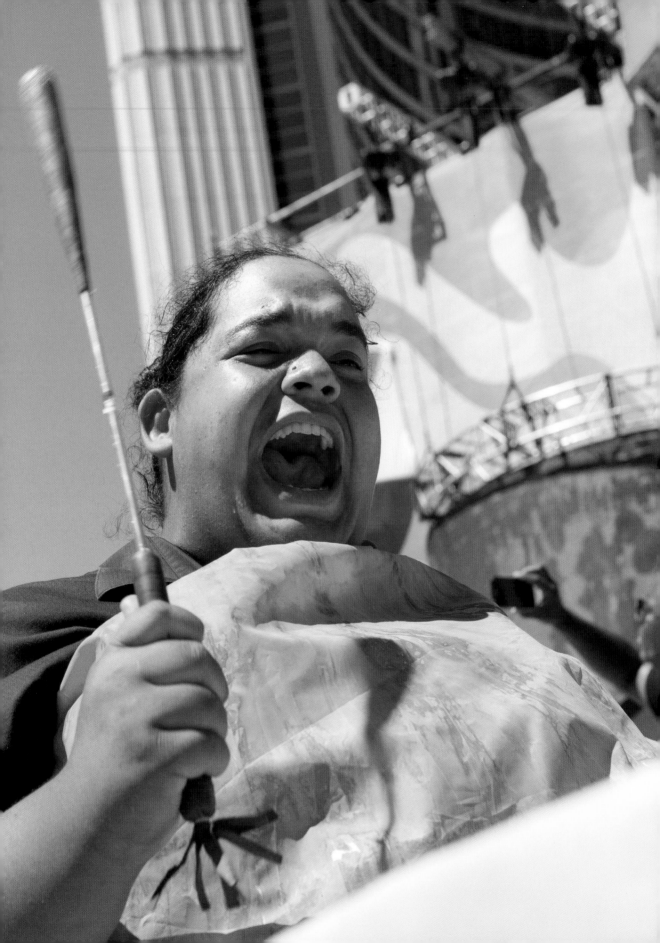

Opposite: Jordan King
on the community
drum for *Ring of Fire*
Grand Entry into
Nathan Phillips Square
Below: *Ring of Fire*
Grand Entry

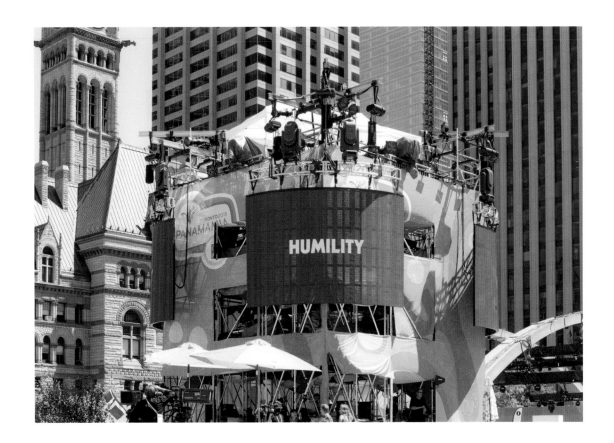

Patterns of Endurance

Patterns are everywhere. They underscore social relations and underlie aesthetic innovation. They are found in the movement of the sun and the moon and they order time and space. Patterns shape our world. Patterns are placemaking: move along the same path everyday and pattern becomes habit; change it up and a pattern of footsteps finds novelty each time. When agency is at stake, patterns can be shapeshifting and paradoxical little creature-teachers: at once figure and ground; base and superstructure; centripetal and centrifugal; random and systemic. And they are malleable: follow their lead as a guide, or rearrange their component parts into new compositions. Patterns inform and are in-formation.

I'll begin this story with a simple pattern: that of a mask easily reproduced with a few scores and folds and cuts. The tools are simple, too: some rivets, an ice pick, and a box cutter. I learned all this from Marlon Griffith, who begins with a prototype, usually made of paperboard—a pattern by all accounts—that is transformed into a complex choreography of materials, objects, and people, and, by all intents and purposes, patterns new social relations in the process. The score, it turns out, is a fold and a cut as much as it itself is a tool.

In some regards *Ring of Fire* was already part of a pattern—albeit an adaptable one, depending on the context, people, and materials at hand. Marlon has been making processions in many cities all over the world—from Cape Town to Gwangju to Nagoya to London and more—an itinerary driven in part by the pattern of the art world, its biennials and its priorities.[3] Patterns on the move, indeed. But these projects, conceived and produced in situ, have themselves evolved out of yet another kind of prototype, one that now travels *with* Marlon. Our origins and influences also pattern our lives. One might liken this

3 I want to acknowledge here the amazing work of Claire Tancons. It is in part due to her sustained curatorial commitment to public performance practice, her dedication to transforming the "exhibitionary complex", and her resistance to staid art historical narratives and tropes regarding genealogies of performance through her provocative writing, that Marlon's works have travelled all over the world. My statement is not to suggest that it is Claire who is placating the international art world but rather those invitations to her to create curatorial projects in different cities and biennials is a pattern coming from the art world's recent interest (and perhaps co-option) of her unique perspective. Marlon's work has figured prominently in most of her "processional" exhibition projects and all but two (Nagoya and Toronto) of Marlon's processions presented in the context of contemporary art have been on her invitation.

Top left: *Ring of Fire: Truth Entourage* sketch, 2015, digital drawing
Top right: *Ring of Fire: Public* sketch, 2015, digital drawing
Bottom left: *Ring of Fire: Love, Honesty, Respect, and Courage Entourage* sketch, 2015, digital drawing
Bottom right: *Ring of Fire: Public* sketch, 2015, digital drawing
pp 100–101: Mask making workshops at SKETCH and Art Starts, Toronto, 2015

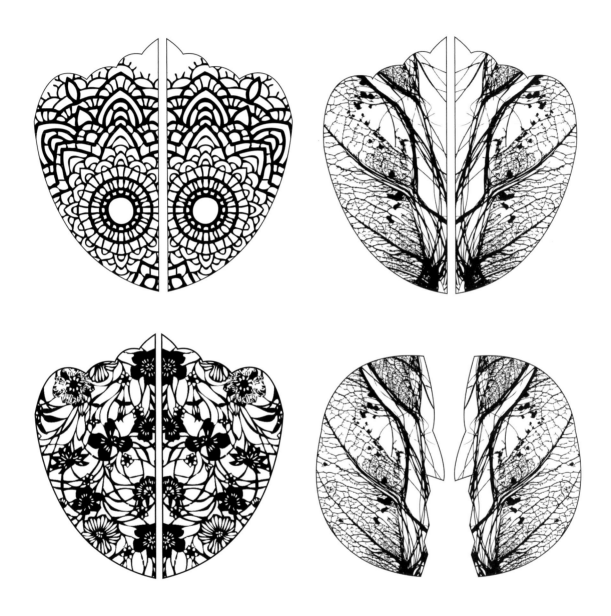

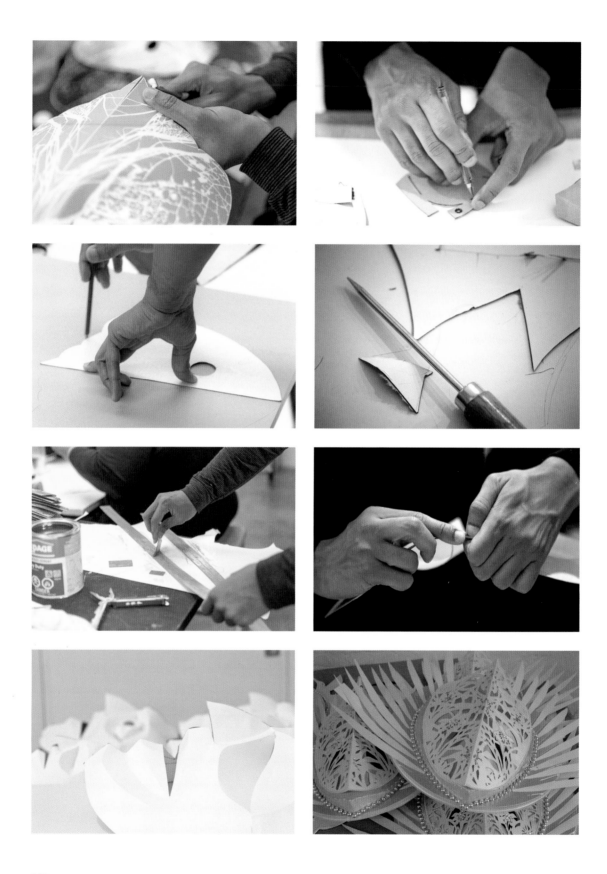

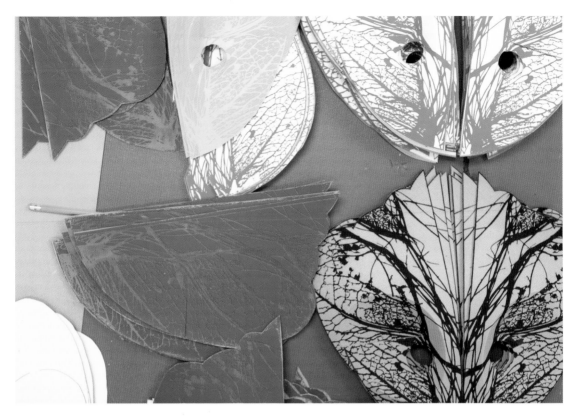

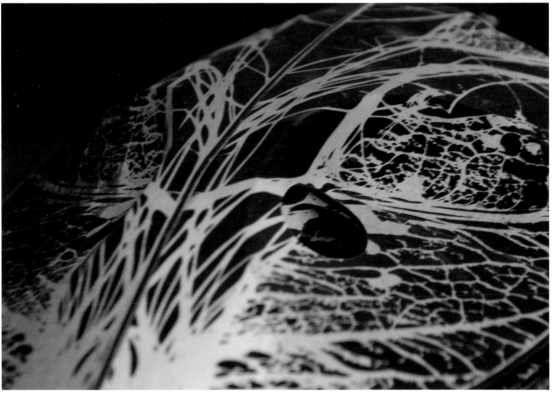

idea to a seed: a self-contained structure with the potential to spread and germinate.

Beginning his career as a masman—so the story goes—Marlon's aesthetic upbringing, as we well know by now, was informed by Trinidadian Carnival, itself the consequence of other kinds of patterns found in the movement of people, commodities, and customs—driven in the Americas by colonialism—and their subsequent convergences: traditions, symbols, strife. Out of this confluence, the composition of a place and the nature of its cultural performances change: new traditions, symbols, and strife arise. But while this context might have patterned Marlon's approach to artmaking, Carnival is no longer the frame in which he presents his work nor, it seems, is it the context in which he wishes his work to be framed and thus viewed and valued.[4] In Toronto, this was made apparent when Marlon missed Caribana, despite overlapping the event on one of his research residencies.[5] It is not the opening up of the Carnival space in which Marlon wants to intervene with his projects—at least it wasn't in Toronto. Rather, it is in what the Carnival space itself can strategically perform at different times and in different contexts that his work now does its work—it operates as a processual agent of change.

So what would it mean to entirely alter a pattern rather than simply adapt it to new circumstance? The story gets a bit more complex. There is already a long history in Toronto of "taking to the streets".

4 We could look at Marlon's non-processional work as mediations on the various conventions and/or qualities of Carnival, its political messaging and its reversals. In *Polite Force*, a performance in Cape Town, Marlon and a band of co-conspirators wore police outfits with the word "polite" written on their backs. These costumes got them access to restricted areas and people approached them as authorities. In *The Powder Box Series*, Marlon appropriated the popular practice of powdering and elevated its class status: his powder patterns were based on luxury brand logos. Immersive installations such as *Symbiosis* reflected upon the embodied and ambulatory nature of Carnival. The list could go on.

5 This upset a lot of Caribbean artists in Toronto, who have long fought for Carnival to be considered an art form funded by the arts councils. Marlon's work represented this potential (and so it should) but Marlon's lack of interest in the context of Caribana (and subsequently working with its practitioners or the parade) created a lot of tensions for this project.

6 According to PG Goheen, Toronto's nineteenth-century public streets were considered "uniquely suitable for the enactment of collective public ceremony" and most organizations and cultural groups staged processions, taking advantage of an "almost unrestrained access to the city streets in order to achieve recognition otherwise unavailable to them". Despite the fact that many erupted into violence or riot, Toronto officials (police or government) "had limited capacity to interfere with unfettered access by groups to

Polite Force,
2004, Johannesburg,
South Africa

New or underrepresented citizen groups have staged processions and parades to rearrange and thus reorder Toronto's social and political cityscape in tandem with its changing cultural composition [6]—from Irish in the 1860s to West Indians in the 1960s to the largest North American Pride parade today.[7] Taking to the streets has been topically driven too: the Bath Raids, 1981, the Toronto Riots, 1992, the G20 protests, 2010, the now-famous Slut Walk, 2011, Idle No More, 2012–2013, and Black Lives Matter, 2015 (and continuing). Processions, as Marlon knows well, are imaginative forms built out of existing social materials and as such are a powerful form of cultural histrionics.[8] By now, Toronto is an aggregate of this dynamic process of change, and, as the most diverse city in the world, our values and our cultural representations have to follow suit. Or, at least I think they should.

Marlon's practice presented a very special opportunity to put this kind of provocation into purposeful action. Diasporic practices change places and these places in turn change practices—an analogy equally applicable to Marlon's projects, given that they discursively follow this pattern of thinking. Just look at the masks: they give form to this relational interstice, each new design arising from the pattern performs as a mnemonic. If this process is one sided, for instance, and a cultural practice does not inflect or infiltrate a place, a frame is placed around it and it becomes a "festival"—I am certain the same scenario applies to Marlon's work, as it walks the line between contemporary art and

the streets". For instance, in 1855 there were no fewer than 22 processions—five of which turned into mob riots. See PG Goheen, "The Ritual of the Streets in Mid-19th-Century Toronto," *Environment and Planning: Society and Space*, vol 11, no 2, April 1993, pp 127–145. It is still easy today: one needs only to fill out an "intent to hold a parade" form and submit it to Toronto Police Services. The local police division will come and escort the gathering with a rolling road closure at no cost to the organizers and very little interrogation as to one's intentions. Of course, there is a difference between holding a parade and staging a protest.

7 The inaugural Caribana parade in 1967 culminated at Toronto's then-new City Hall. According to newspaper reports at the time, the route was

a symbolic one for the organizers, who "wanted to demonstrate that a minority group with little political clout belonged on major city arteries, while the backdrop of City Hall would show that the community was an integral part of the new Canada". Bradburn, Jamie, "Come Out to Caribana '67", *Torontoist.com.*, 1 August 2015, accessed 26 July 2016.

8 Susan G Davis, who wrote extensively on the history of parades in nineteenth-century Philadelphia would also call them "public dramas", marking the form as important processes powerful enough to "propose ideas about social relations". Davis, Susan G, *Parades and Power: Street Theatre in Nineteenth-Century Philadelphia*, Berkeley, CA: University of California Press, 1988, p 4.

vernacular tradition. Caribana, or rather, Toronto Caribbean Festival, as it is now titled, is a local case in point.[9] How cultural forms of display are organized and framed and their principles then taken up have an effect on the social world of a place. The social world of this place, Toronto, it turned out, had a profound effect on Marlon's practice too.[10]

Ring of Fire, Marlon's procession "for Toronto", was not about what diasporic practices have done to this place or what this place has done to them, however.[11] It sought to articulate the potential of what this place, Toronto, could do *with* these practices to new effect through their mixing today. Similarly, this project was not about creating new genres of performance or new discourses of art; its purpose was to enact a new tradition in and for Toronto by engaging with its many traditions and cultures, from First Nations, to immigrants, to first, second, and third generation Canadians.[12]

To create a new tradition, though, one must seek out a new frame for its public presentation, even if (or especially because) in Toronto this "new tradition" took on such a recognizable form vis-à-vis Marlon's work.[13] Coincidentally, Toronto was planning the Pan American Games

9 While not possible to expand on in the context of this essay, it is a curious fact that Pow-Wows are both the thing itself and the name of the event. Pow-Wows are never contextualized as a First Nations' "festival", for instance. Like the other performative forms of anticolonial cultural resistance brought together in this project, especially in the practice of capoeira, a Pow-Wow was a means of keeping Indigenous traditions alive while subverting Canadian Government sanctions of their cultural activities—sanctions that forbade First Nations from practicing their cultural traditions (singing, dancing, etc) as well as, in the repressive (and devastating) residential school system, speaking their languages. Pow-Wows also built allegiances between the various groups of First Nations located in different parts of Canada, further building strength amongst their peoples. Labelling Caribana as a festival is to deny Carnival's potential for dissent and social critique, which in turn prevents it from performing an emancipatory

function within the context of Toronto. Caribana was censored from the onset, with a volunteer committee formed to deal "with issues like muting the raunchier aspects of Carnival so as not to offend Toronto's prudish tastes" ("Come Out to Caribana '67"). Caribana is one of the city's most lucrative cultural "festivals" with more systems of control set in place each year (barricades, ticketed events, etc).

10 The materials Marlon used to create the costumes and masks also changed over the two-year period of *Ring of Fire* and these changes were apparent in the procession. In the three months leading up to the procession, Marlon participated in the prestigious Louis Odette Sculptor-in-Residence program of the School of the Arts, Media, Performance & Design at York University. Here, he was able to work in a sculpture studio with the technical support of instructors and technicians, as well as assistance from sculpture students. Laser-cut polystyrene, water-bent wood, and even

Portrait of Wisdom
Entourage member
Carleen Robinson from
Art Starts

at the same time as we were devising Marlon's project. This made us wonder: how have past performative forms of colonial cultural resistance developed in the Americas evolved? How could they become possible future practices in the here and now? And what could this mean for developing new methodologies for solidarity in the context of a culturally mixed Toronto? *Ring of Fire* was the first project whereby Marlon would work with individuals and groups with no natural affinity and mobilize his practice as a means to actively bring them into meaningful relation.

As the Pan American Games, itself a symbolic inter-hemispheric spectacle, brought together hundreds of athletes from across the Americas, we set out to mix together practices and techniques drawn from capoeira, Pow-Wow, spoken word, and, of course, Carnival, in order to engage hundreds of local citizens in the creation of new symbols that reflected and refracted an unprecedented pattern of solidarity cultivated through our project. We reframed resistance practices—themselves remarkably similar in structure and purpose— around disability rights and decided we would take to the streets for the opening of the Parapan American Games. For this new tradition,

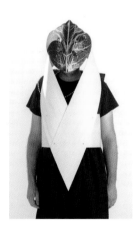

Portrait of Wisdom Entourage member Douglas Hurst from Art Starts

cast bronze opened up new aesthetic possibilities for his work. It was also interesting to watch the collective mas' camp transform into the solitary artist's studio. It seemed to me that Marlon enjoyed working alone immensely. This sculpture residency opportunity also seemed to come at a very strategic time for Marlon as his own aesthetic was changing—from patterns and shapes inspired by the Caribbean to those inspired by Japan. Note the difference between the costumes for the Entourage of Wisdom (mounted on backpacks) and the costumes for the Entourage of Courage, for example.

11 As businessman Trevor Clarke, one of Caribana's early officials, stated, "integration is something that can only be effected when people can give as well as take. Culture could be the beginning of this. Unless I can project myself into your culture and you into mine, we are not equal" ("Come Out to Caribana '67").

12 Eric Hobsbawm describes the "invention of tradition" as innovatory moments and as evidence of dynamic social and cultural change because it utilizes old models for new purposes. Hobsbawm, Eric, "Introduction: Inventing Traditions", *The Invention of Tradition*, Eric Hobsbawm and Terence Ranger eds, Cambridge: Cambridge University Press, 1983, pp 1–15.

13 Large-scale games must also be considered as transnational cultural performances with their own symbolic ritual practices: opening and closing ceremonies; the raising and lowering of national flags; the procession of the athletes; etc. We intentionally wanted our project to be framed within the Games' overarching dramaturgy. In the marketing material for *Ring of Fire*, the procession was billed as being "staged at the Parapan Am Games". Para-sports, which require the participation of more than one person working together, were one of the inspirations for *Ring of Fire*.

it wouldn't be one group taking the stage in Toronto as a means of cultural "integration", but Toronto together performing as a city on the world stage under the auspices of these games.[14] In doing this together as Torontonians, we furthermore set out to show the world that the procession was no longer an exclusively "able-bodied" form of public address.[15] As a consequence, Marlon's masks and costumes had to find a new prototype and the project had to innovate a new methodological framework.

Of course, all this is much easier said than done, though the doing was a key consideration for Marlon's practice, particularly as it took on the challenge of designing costumes for different cultural groups—Indian mas', for instance, just wasn't going to fly here— or for different body types, ones that would fit *and* function for a variety of mobility devices. While cultural "purity" was *détourned* in the service of formal novelty and the creation of mixed cultural codes and symbols, authenticity drove the project's process and ethics. Affiliation couldn't simply be stated symbolically through the creation of costumes and masks. Of course it would be that too, but only after the social bonds that *could* give rise to these new symbols were already sealed. The bringing together of diverse individuals and groups—from the traditional landkeepers of Toronto, the Mississaugas of the New Credit First Nation, to spoken word poets from three of Toronto's underserved neighbourhoods (themselves having no affiliation except through negative media representations), to persons with disability and Blind and Deaf persons—had to be real, especially if the project was to be more than just a mere demonstration of

14 Interestingly, John MacAloon argues that games such as the Olympics are a "ramified" performance type with spectacle as an overarching performance genre that encompasses all others: festival, ritual, play, etc. As such, large-scale international/ hemispheric games might be the most appropriate organized genre of cultural performance for today's "global" world: these games have become a forum that allows the world to work through its issues while simultaneously appealing to spectators' emotions as a vehicle for collectivity. (The fact that the everyday world often enters the games [boycotts, bombings, etc] also contributes to this). I was particularly interested in how *Ring of Fire* might function differently when placed inside the framework of the Pan/Parapan American Games. See "Olympic Games and the Theory of Spectacle", *Rite, Drama, Festival, Spectacle: Rehearsals Toward a Theory of Cultural Performance*, Philadelphia: Institute for the Study of Human Issues, 1984, pp 241–275.

multiculturalism. Throw out the prototype! But, in fact, there wasn't a template for Marlon or myself to follow in a project that was patterned by a lived and interconnected world of relationships, especially between individuals and groups with unique, yet not mutually exclusive, human rights issues. This intersection was vital to understanding the "how" of this project's production and the kind of "performance" it would ultimately orchestrate.

Instead of starting with a series of scores, folds, and cuts, or even a single mas' camp that would act as a hub for the production of Marlon's overarching design—as has generally been his strategy for previous projects—*Ring of Fire* first had to devise the conditions under which this project—not just Marlon's work—*could* do its work. Given its particular history, Toronto should no longer allow for projects with narrow participatory frameworks, and Marlon's authorial approach to designing his processions simply wouldn't translate to this place: First Nations were not going to sign up to be in a procession that used the Seven Grandfather Teachings as a theme without they themselves playing a determining role in its shaping; persons with disability were not going to take to the streets without knowing their particular needs would be accommodated and their positionality duly acknowledged and respected; youth from different suburbs across the Greater Toronto Area were not going to get involved—let alone be interested—in a project that took place from the point of view of the city's downtown core. As a Torontonian myself, it was my role to broker these historical, social, and geographical complexities and to strategize the ways in which all of us might, in fact, curatorially engage with our city

15 This was a main goal of *Ring of Fire* and held a special place in Marlon's heart. He recounted to us several times that his father would always watch Carnival in Trinidad but never participate because of a disability. In many ways, this observation undercuts the ideal that Carnival is a space that eliminates the distance between participant and spectator. It can, but only if the spectator can imaginatively project their participation in the first place. We set out to ensure that *Ring of Fire* would be designed with disability in mind.

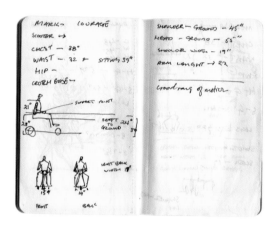

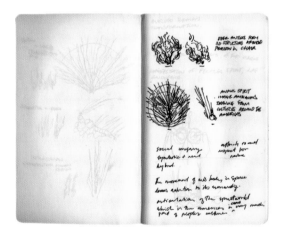

This page and opposite:

Ring of Fire sketchbooks,
2015, ink on paper

Symbols of Endurance

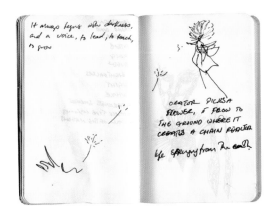

through Marlon's project.[16] I would be the one to bring the various individuals, groups, and other organizational entities—arts-based and otherwise, each with their own particular mandates, ethos, and approaches to artmaking into dialogue and inspire them into action around the artist's proposition.[17]

This process—both political and practical—was, in some regards, more important than the final outcome of the project itself. Or, to put it another way, the project's outcome had to *embody* its organizational attributes before its "new symbols" could endure. Designing *for* became designing *with*. This was as true for the way each group and organization participated in shaping the project as it was for Marlon's design process.[18] Of the 300 participants in the *Ring of Fire* procession, 150 were core collaborators, their roles and costumes custom-designed, not just custom-fit. A consequence

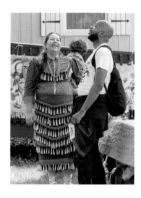

Above: Cathie Jamieson and Marlon Griffith in New Credit, summer 2015
Opposite: Carolyn King of the Mississaugas of the New Credit First Nation explains the Covenant Chain Wampum Belt at the old Band Council Chambers in New Credit, 2015

p 112 top left: *Ring of Fire: Wisdom/Moose* concept drawing, 2015, watercolour on paper
p 112 top right: *Ring of Fire: Respect/Wanda* concept drawing, 2015, watercolour on paper
p 112 bottom left: *Ring of Fire: Love Entourage* concept drawing, 2015, watercolour on paper

16 In saying this, I want to make an important distinction between curating as the work done by a curator and the curatorial as a methodology for social and civic engagement. In *Ring of Fire*, "cultural work" was the framework for the project, a project whose purpose was to also demonstrate that any particular cultural frame is neither fixed nor ontologically given. This meant curatorially engaging in the city's existing social structures and in the everyday lives/realities of its citizens by bringing them (structures/citizens)—not just the individuals and groups—together into a new kind of proximity. To my mind, a curatorially engaged social and civic approach to cultural work brings together elements of the civic and social sphere so that individuals and groups might themselves create new ways and means of navigating the existing spaces, structures, and bureaucratic systems of their city and the cultural organizations that are supposed to represent them. If curating is to find pragmatic and aesthetic solutions to issues of representation by changing the regimes of visibility or by inventing frameworks to accommodate new forms and thus new ways of seeing, curatorially engaging in the civic and

social field means reorienting those issues and potentialities away from an individual, ie the curator or the artist, toward the entire team of collaborators as cultural producers (even those not involved in the "arts", per se) now in relation to the city, not just the gallery or institutions of art. Repositioning the role of the curatorial—that is, what it means to think curatorially about one's city by bringing its different functions and citizens together—requires everyone's involvement. Finding ways to "fit together differently" was key to making a project like this relevant in a place like Toronto at this particular moment in time, especially considering Toronto's history of street processions and festival culture.

17 This is not to take credit for *Ring of Fire*. It is to highlight the fact that Toronto's history, complexities, and values were something I had to contend with in order for Marlon to be able to make the kind of project he proposed in/for Toronto, where I live and work. This is also to openly acknowledge that Marlon doesn't live in Toronto (before *Ring of Fire* Marlon had never been to Canada), which means he was only here periodically (though a lot: January–February 2014, June–July

Symbols of Endurance

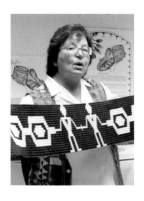

of working together over two years—a first for Marlon—was that the costumes *became* the people for whom they were designed. Thus, it was not so much the costumes that were brought to life through the performance on the street but rather the individuals who were brought to life through the costumes, with their particular personalities dramatized through procession. Furthermore, the procession was structured around the role each person played in the project. Each of the seven bands—one for each teaching—was comprised of a Sentinel, played by one of the core collaborators from each group; an Orator, played by one of the spoken word poets with an accompanying youth signer; a ten-member Entourage, comprised of people who worked on the costumes, masks, and workshops; and a group of 30 members of the general public who signed up in the weeks leading to the procession— a process we saw as a symbolic gesture of solidarity.[19]

p 112 bottom right: *Ring of Fire: Truth/Cathie* concept drawing, 2015, watercolour on paper

p 113 top left: *Ring of Fire: Courage/Berma* concept drawing, 2015, watercolour on paper

p 113 top right: *Ring of Fire: Honesty/Suviana* concept drawing, 2015, watercolour on paper

p 113 bottom left: *Ring of Fire: Wisdom Entourage* concept drawing, 2015, watercolour on paper

p 113 bottom right: *Ring of Fire: Honesty Entourage* concept drawing, 2015, watercolour on paper

2014, November–December 2014, May–August 2015). In the interim I maintained the relationships forged through this project. This was not such a hardship. Marlon's project provided an opportunity for me to meet new people, engage my city differently, and learn new ways of working here—ways to which most art projects only pay lip service. This concept of the "parachuting artist" comes from the art world. In making a project in and of a place, the person that lives in the place must have a responsibility to it: Marlon and I had to do this project together. Doing this together didn't always mean we shared the same perspective. *Ring of Fire* was a project that was based on principles of difference and that difference manifested itself through our respective working practices/perspectives as much as in/through those of our collaborators.

18 For instance, a year in advance of any actual "production", Marlon and I approached the Mississaugas of the New Credit First Nation to discuss their teachings and to initiate a discussion regarding the costumes: what were their thoughts on wearing costumes that were in part modeled on their regalia and the colours of the Medicine Wheel? Or on the idea that non-Aboriginal people

would inhabit these "representations" in a "cultural performance"? *Ring of Fire* could not reproduce the pattern of cultural appropriation that so many acts of "solidarity" actually enact. This notion of symbolic solidarity was reiterated by the disability organizations we met. It was imperative to make a project that was accessible. The procession couldn't simply put disability on display. This meant that the project itself had to be structured around the participation of Deaf or Blind persons (everything from ASL interpretation to accessibly designed marketing material), ensuring that the project embraced these values. This had an impact on the masks and costumes, too. Marlon was in a perpetual state of revising his designs as he took seriously this input, learning about various mobility devices as well as being careful not to "represent" First Nations regalia. For instance, a bustle, worn by men, was proposed for the Sentinel Truth, played by Cathie Jamieson. While she was open to this idea, Marlon was told it is only ever made of eagle feathers, which are sacred. Marlon opted not to design a bustle so that he wasn't creating a "fake" version of an essential component of their regalia.

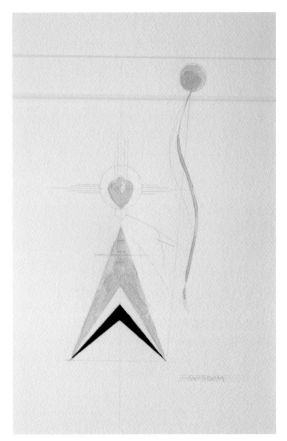

COURAGE

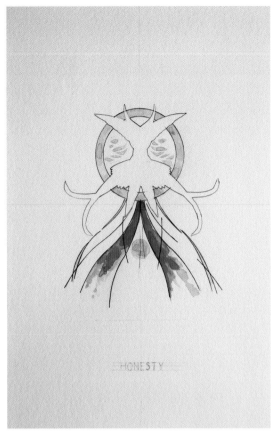

HONESTY

HONESTY

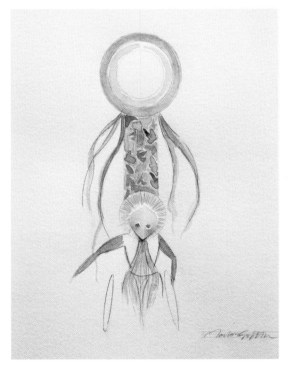

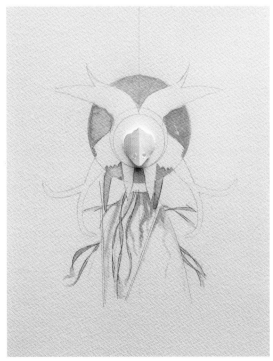

Using symbols, shapes, and colour as motifs that repeated throughout the costumes, Marlon encapsulated the interconnected relationships of his collaborators. Each person played a role within the procession, which as a whole began with the sun and ended with the moon. Each costume was intended to elevate its bearer, too—perhaps even more than is Carnival's convention given that Marlon knew each person intimately. The costumes strategically played with a very well known Carnival trope: reversal. For instance, designed to take up as much space as possible, mobility devices were adorned with large and sprawling forms, overemphasizing their street presence. The Orators were given megaphones to amplify their messages and speak back to the city—enacting a movement from periphery to centre, so to speak. To Marlon's mind, mobility devices were no different than chariots and the Orators messages no different to the Mayor's.[20] Players were equals. The Sentinel's and Orator's costumes, for instance, symbolically showed that both were equally important to the overall cultural/social/political landscape of Toronto. This design strategy underscored the fact that "mentorships" could arise across cultures. Elder Duke Redbird's chariot and costume were personifications of Wisdom (an icon designed by Marlon as a triangle with a circle on top). Young poet Moose, the Orator for Wisdom, had this symbol inscribed on his chest. Moose was an Elder in training, the role of spoken word poets in his community being also that of a sage. The costumes of each Entourage repeated elements found in the Sentinel's and Orator's costumes, too: the Entourage players were our cultural leaders in training, now with a new set of role models to learn from and thus to follow. First Nations, persons with disability, and young spoken word poets from

Top: Truth Sentinel Sheila Boyd tries on her costume in the sculpture studio at York University, 2015
Bottom: *Ring of Fire: Wisdom Icon,* 2015, digital drawing
p 116 top: *Ring of Fire: Humility Sentinel/Torrance* technical drawing, 2015, pencil on vellum
p 116 bottom left and right: *Ring of Fire* sketch, 2015, ink on paper

19 The 30-member group of public participants followed most closely the conventions of Carnival. Signing up in advance, these participants could choose which band they wanted to be in. However, this choice was based on the teaching, not the particular design. The masks the public wore were based on the costumes created for the main participants; they were the only "anonymous" participants in this regard (even if, by virtue of their home-made quality, each mask was slightly different, but not individualized). For the most part these participants were able-bodied members of the art community. It is important to note that the pace of

the procession was also strategically organized to take its cue from the persons with disability who played most of the Sentinel roles.

20 Duality was another theme that ran through the procession: hard/soft, dark/light, vulnerability/protection, sun/moon, etc, and this was expressively manifested through Marlon's costume designs. This duality was intended to challenge perceptions and reverse assumptions: a bear, the totem for the Courage Band, clad all in black, was both fierce and sensitive. Both the Sentinel and Orator wore matching masks with protruding bear claws, yet the mask worn

Symbols of Endurance

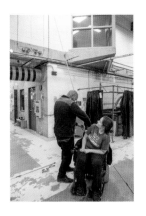

Above: Love Sentinel
Melissa Addison-Webster
with Marlon Griffith in
the sculpture studio at
York University, 2015
p 117 right: *Ring of Fire:
Wheelchair Interaction*
concept sketch, 2015,
ink on paper
pp 118–119: *Ring
of Fire: Seed/Love,*
2015, seed

the margins became our cultural leaders, while vernacular forms of cultural resistance became our cultural references. *Ring of Fire* was an index of this visionary assemblage.

In early 2014, *Ring of Fire* began with a seed. Not only in the metaphorical sense of a seed of an idea being planted in Marlon's mind by Métis Elder and Wisdom-keeper Duke Redbird, who told Marlon about the Seven Grandfather Teachings, but also a real seed—one he found in Trinidad in 2006 and has carried around in his sketch-book ever since. In planting the seed-idea, Duke recounted a parable about the "food forest" as a signature of the Seven Grandfather Teachings, written into the land as an ecology of relations. Wisdom, for instance, is manifested in the tall trees: the towering oaks and walnuts. With their tops reaching to the sky and their roots spread deep into the earth, these trees could see far into the future and back through time. Duke pointed out the shape of the walnut itself as an index: a brain. Courage is manifest in the smaller trees—the survivors—apple and pear trees, for instance. Despite facing drought or winter, these smaller trees persist, bearing fruit again and again from their branches. Respect is the bushes and the berries, all different sizes, shapes and colours, growing and thriving together. Honesty is the food that grows on the ground—mushrooms, squash or cabbage, for instance— food that announces it can be eaten and thus trusted. Humility is the plants that grow just below the earth, hidden and humble, like the potato. Love is the vines on which grapes and beans grow: woven, spreading, interconnecting. As elements of an overarching forest canopy or "field", each plant exists in living connection to the others. Each teaching encompassed all the others. Marlon's seed-object

Courage Orator mask at
the sculpture studio at
York University, 2015

by the Orator also contained a little mask inside it with fabric tears streaming down. The Entourage wore bent wood shapes that wrapped around their bodies like blankets. Costumes in the form of mobility devices also played this expressive role. Either they were pushed and thus required the support of others, as was the case with Wisdom's chariot or Honesty's hummingbird structure, or they pulled something, which gave the device agency. For instance, the Courage Sentinel had a train of bear claws attached to the back of Mark Brose's scooter and the Humility Sentinel pulled along a structure with a large canopy attached to Torrance Ho's wheelchair. This canopy provided shelter for the Entourage, who were capoeira players, itself a game of dualities (ie restraint and attack).

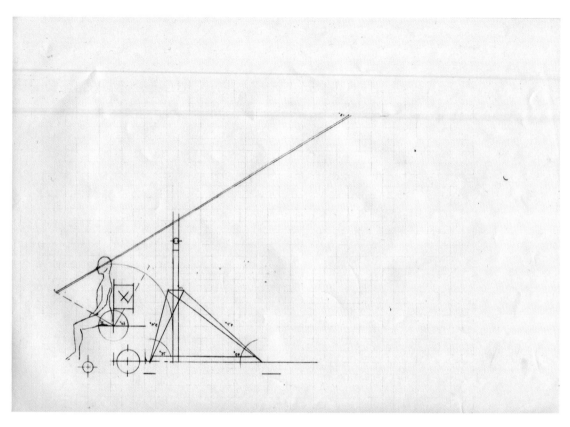

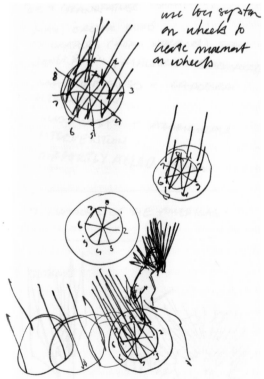

use low system
on wheels to
create movement
on wheels

Symbols of Endurance

became the prototype for the Love Band in the procession.[21] And Duke Redbird was invited to play the Sentinel Wisdom.

The food-forest wasn't an idea or an object or a character represented in the procession, however. It was symbolized in its structure. The interconnected ecology that the food-forest signified also became a guide for the way in which the project was organized and thus "grown". Naturally, this required quite a bit of creative cultivating. This groundwork would have a lasting impact on the city, however, well beyond the specific time-space of the project itself. The activities—from wheelchair dances to feasts to community consultations—also had a profound impact on the design of the costumes and masks. The procession became a mnemonic for the project and a contemporary meta-communicative manifestation of the Seven Grandfather Teachings.

Top: Wisdom Sentinel Duke Redbird just before *Ring of Fire* procession
Bottom: *Ring of Fire: Wisdom Sentinel/Duke* comprehensive sketch, 2015, digital drawing
Opposite: *Ring of Fire: Leaf/Wisdom Entourage* and *Public Masks* source, 2015, leaf

21 On the one hand, the Seven Grandfather Teachings became the basis for the structure of the bands in the procession and a signature written in the mas', symbolized through repeating patterns in the costumes. On the other hand, these teachings provided the ethical framework for the project and informed the way in which it was organized. The individuals and groups involved in *Ring of Fire* likewise (per)formed an ecological system of relations, too, each in-forming the overarching ideal of this project through their unique yet interconnected mode of participation in it.

From spoken word poets learning from First Nations and Deaf youth who signed the poems in the procession, to institutions and organizations learning from persons with disabilities (and becoming more accessible in the process), to mixing integrated dance with traditional forms of capoeira, to combining vernacular, community, and contemporary art practices, to the creation of custom-designed costumes for a spectrum of mobility devices by youth from across the City of Toronto, *Ring of Fire* innovated a new kind of embodied pedagogy. Through over 200 workshops in spoken word, integrated dance, capoeira, music, and maskmaking across five different community organizations from across the Greater Toronto Area—where multiple mas' camps were dispersed—we slowly brought the project's collaborators together and did something else as well.[22]

Opposite top: Truth Orator Zeinab Aidid and Humility Orator Nadia Adow (performing) at Art Starts, 2014
Opposite left middle: Respect Entourage member Beverly Smith and Love Entourage member Alexis Pastuch practice capoeira in the dance studios at SKETCH, 2015
Opposite left bottom: Truth Entourage members Rachele King and Michael O'Connell in SKETCH recording studio creating the soundtrack for the *Ring of Fire* round dance at Nathan Phillips Square, Toronto, 2015
Opposite right bottom: Humility Entourage member and Capoeira Mestre Marcio Mendes

22 The collaborators were Success Beyond Limits, COBA, The Malvern S.P.O.T. (spoken word), Art Starts (costumes and masks), and SKETCH (costumes, masks, music, movement).

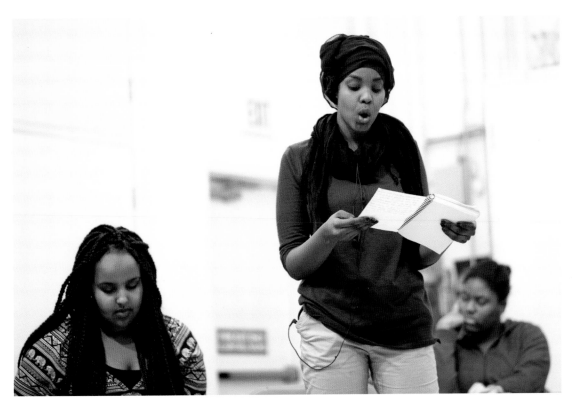

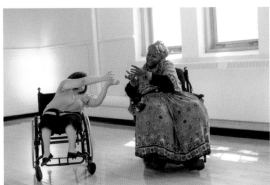

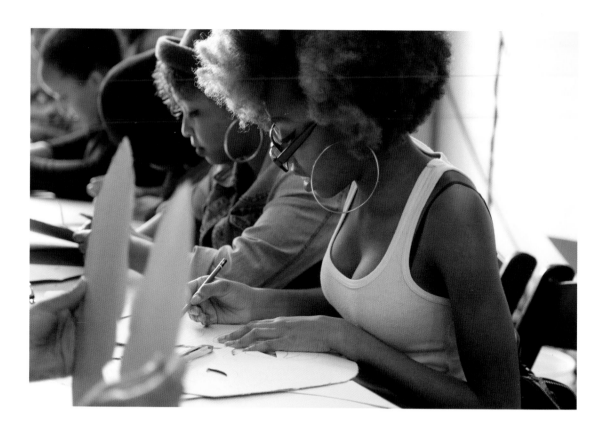

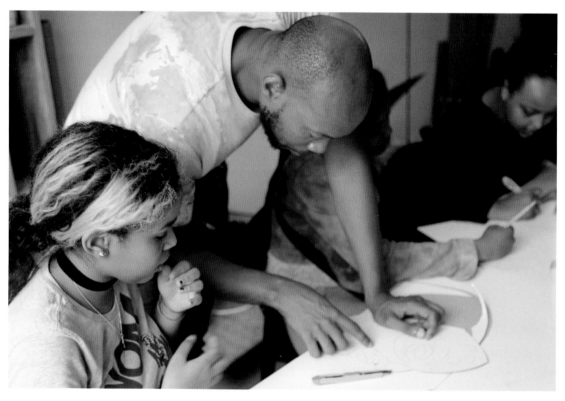

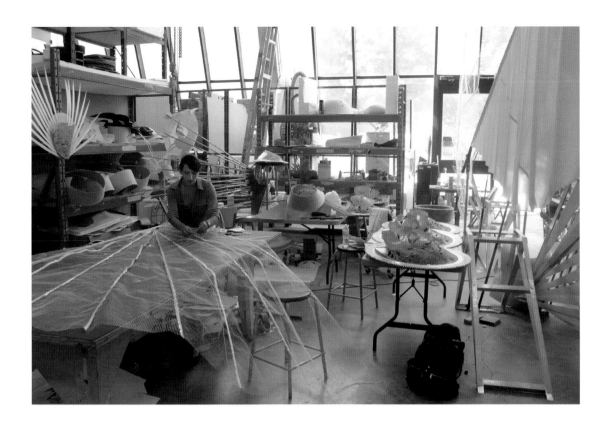

If the mas' camp is a place where tradition is passed down, new skills acquired and exchanged—what Marlon calls an each-one-teach-one workshop—and social and cultural bonds sealed, we also used these production spaces as platforms to perform the ideas proposed by Marlon's project on a different kind of scale: each part of the project would be a mentorship opportunity and a means to model new modes of civic participation. We developed a year-long spoken word mentorship program in three underserviced neighbourhoods across the Greater Toronto Area.[23] We hosted monthly poetry slams in partnership with existing youth-organized spoken word events in each neighbourhood as networking opportunities for young people across the city. Furthermore, because the "junior poets" in the program were to use the workshops to write new rhymes based on the Seven Grandfather Teachings (but from their particular points of view), they needed to learn about these teachings from Duke Redbird and the Mississaugas, who, in turn, learned from these poets. Movement became a tool and a medium as young people navigated their city differently, travelling to different neighbourhoods to strut their stuff, but also to New Credit (none had been to a reserve before) and to various community organizations that hosted the workshops in locations across the city. These young people not only learned about First Nations culture—something they weren't taught in a school system still dominated by a colonial curriculum—but also about other cultural resources and spaces in their city for potential projects in the future.

p 124: Maskmaking workshop with Art Starts "Sew What?!" program at Marlon's first mas' camp, located at the Drake Hotel, Toronto, 2014
p 125 top: Wings being made for Love Sentinel during the month-long mas' camp Marlon led with upper year sculpture students as part of the Louis Odette Sculptor-in-Residence Program, School of the Arts, Media, Performance & Design, York University, 2015
p 125 bottom: Arrows for Respect Sentinel costume at sculpture studio, York University
Opposite top: Members of Alternative Routes from New Credit explore possible soundscapes for the Seven Grandfather Teachings at the SKETCH recording studio, 2015
Opposite bottom: Capoeira workshop at SKETCH, 2015

23 The Art Gallery of York University has a long association with spoken word poets in Jane-Finch, the neighbourhood in which the gallery is located. This is to the credit of the ongoing, decade-long work of Education Assistant Allyson Adley, who organized the year-long spoken word mentorship program for Marlon's project. Marlon had met a group of poets who were involved in a different project with the gallery and he asked how they would like to be involved in his—they indicated a desire to meet other youth in two other neighbourhoods: Regent Park and Malvern. All of the poets took an immediate liking to Marlon, who became a role model as many of these first generation Canadians are of Caribbean heritage. The mentorship program was designed to bring together a wide range of intergenerational poets from all of the neighbourhoods, with senior poets teaching the junior poets and they in turn running open workshops in writing for emerging poets. The poets who participated in this program played roles in the procession as members of the Entourage in the band of their choice.

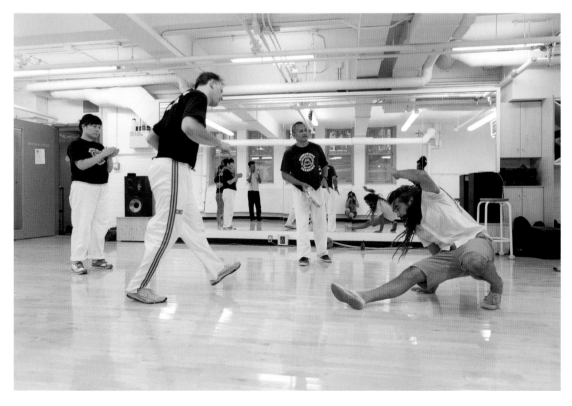

The same was true for the relationship forged between Picasso PRO and Equal Grounds, an integrated dance company and a disability collective, respectively. Equal Grounds had an emerging dance program and members of the collective were keen to work with professional dancers and be a part of the procession.[24] In the first year of the project, Marlon and I had met with disability advocacy groups, service organizations, and, of course, artists to rethink what it meant to "take to the streets" from the point of view of people for whom the streets were not, in fact, designed for them to take to so spontaneously. Rose Jacobson from Picasso PRO became one of *Ring of Fire*'s mentors, playing an instrumental role in making it barrier free. It was Rose who brought in the group of young Deaf/HOH signers to work with the spoken word poets, for instance. Through integrated dance workshops, we brought Picasso PRO and Equal Grounds together. Community Living Toronto (CLT), a non-profit social services organization, joined our ever-growing circle of collaborators as volunteers. Not only did they recruit new participants for the workshops and procession—individuals who had never before participated in a contemporary art project—CLT also provided support workers, ensuring everyone in the project felt supported.[25] No one would have "special needs" in a project that viewed participation as a potential agent of systemic social and cultural change.

As an important method of non-verbal communication for the project, movement became an integral strategy for working across cultures, abilities, and geographies—the procession becoming the ultimate expression of this. Through workshops in capoeira Angola, led by Brazilian Mestre Marcio Mendes, we practiced a poly-reflexive

Top: Art Starts' "Sew What?!" program participants and spoken word poets learn about the Seven Grandfather Teachings with Elder Duke Redbird, 2014
Bottom: Wheelchair dance party at SKETCH, 2014

24 Even if we modelled ourselves after trees and bushes of the "food forest", *Ring of Fire* was organized rhizomatically. Our collaborators came through various networks or simply through coincidence. Equal Grounds had contacted me because they had heard about *Ring of Fire* from TETRA, an organization devoted to creating custom-made devices to meet very particular needs of the disability community that Marlon and I had met in early 2014. Marlon and I approached TETRA because of the way in which they framed their work as "participatory issues that require collaborative solutions".

25 CLT also came to the project through circuitous channels. A support worker had seen our call for participants and contacted me to know more about the project. She forged the link with CLT because she recognized in this project a reciprocal opportunity: clients of theirs could be a part of a very visible project and they, in turn, could help us with resources we would not have access to otherwise. The entire project grew this way and in part this is why this project became so special for Marlon and me.

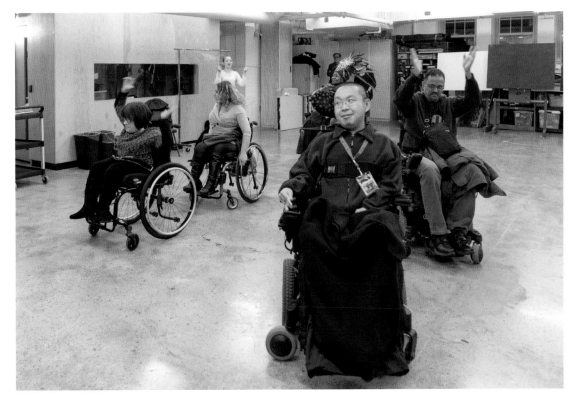

and slow form of inter-action, re-enacting the embodied call-and-response process of learning that this practice promotes. The relational flow of exchange between bodies in capoeira Angola is designed to keep a process open and ongoing: a meta-pattern for *Ring of Fire*. Through these workshops, countless collaborators culled lessons from the traditional philosophy of capoeira as we found our resistance and strength in the roda. In the three months leading up to the procession, we brought together the integrated dance and capoeira workshops, the borderline between our activities dissolving into an integrated experience. Together we devised a series of movements, combining techniques learned through these workshops, that everyone could perform in the round dance we had collectively conceived and orchestrated for our arrival at City Hall. The circle was already part of a larger pattern, present in all of the practices this project drew together: the round dance of the Pow-Wow, the roda of capoeira, the calinda of Carnival. Circles permeated the procession too: the masks, the mobility devices, the moon cycle, and more.

Entering the grounds of Toronto's City Hall at the close of our procession, we symbolically enacted our own rite of passage, now publicly manifested in a moving display of spontaneous communitas. The Mississaugas entered the square first, placing their community drum at the centre. The drumming began. It was time for our procession's Grand Entry.[26]

Top: *Ring of Fire: Seven Grandfather Teachings, Round Dance Arrangement,* 2015, digital drawing
Bottom left: The beginning of the Grand Entry
Bottom right: Drummers from Alternative Routes enter Nathan Phillips Square to begin Grand Entry

26 A Grand Entry marks the beginning of a Pow-Wow. Generally, an Eagle Staff leads the Grand Entry, followed by flags, then dancers, all the while the hosts' drums sing an opening song. This event is sacred in nature. The Grand Entry into City Hall was an idea of the Mississaugas and was thus an incredible honour for all of us in the procession. It is perhaps unprecedented that a First Nation would offer this form for a mostly non-Native group. Following a Grand Entry, the MC of the Pow-Wow will invite a respected member of the community to give an invocation. We had written a script to have the official announcers of the Games read ours. Duke Redbird then gave a public address to the crowd.

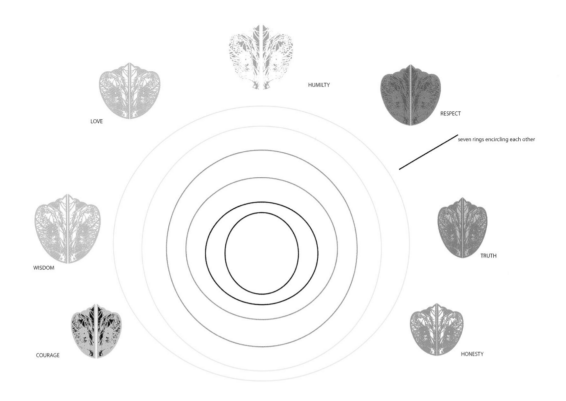

LOVE

HUMILTY

RESPECT

seven rings encircling each other

WISDOM

TRUTH

COURAGE

HONESTY

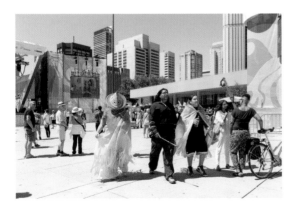

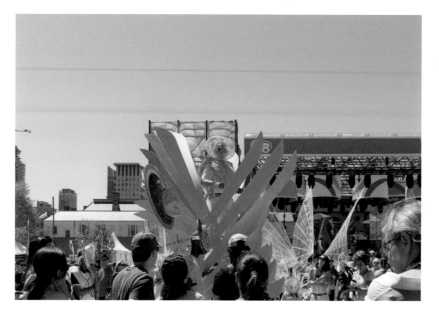

Left: Wisdom Sentinel Duke Redbird performs his poem "The Dance" as a public address at Nathan Phillips Square
Opposite: Moon Orator Kareem Bennett and ASL Signer Hope Rehman perform at the end of the round dance at Nathan Phillips Square that marks the end of the *Ring of Fire* procession

Band by band, we entered the square and took our positions. Duke Redbird delivered the customary invocation:

> The drum has started beating
> The chanting: first high, then low, then high again.
> The drumstick is just a blur upon the painted Buffalo skin.
> The chanting; the haunting cry that stirs dead hearts and moves deep passions
> Abandoned down in the dark recesses of the soul.
> I close my eyes and darkness has disappeared!
> Colour now is everywhere!
> Leaping and bounding; laughing and twirling;
> Rising and falling; spinning and curling
> Rhythmically and symmetrically the chant and the drum.
> My voice and my heart
> If they live, then I live!
> Life and death; love and sorrow
> I am a man and a god, too.
> Joy, harmony, and freedom
> I AM FREE AND I DANCE!

—Duke Redbird, *The Dancer*

Pulling the public into our circle, we performed the largest round dance in Toronto's history.[27] *We* had all come full circle.

Collaboration was not an end in and of itself in *Ring of Fire*. Bringing together unprecedented partnerships, processes, and people was a means to assert our collective presence in the future time-sense of Toronto. The behind-the-scenes production and the final procession, both were rehearsals: for the creation of new social relations, on the one hand, and for new ways of participating in the civic and cultural life of our city, on the other. This display of 300 people, all from different backgrounds, ages, abilities, and cultures linked together through costume and movement, was an image of Toronto's potential. The project wasn't about belonging to a place but belonging *with* it. The procession made visible our achievements. After two years of working, learning, and making this project together, on 9 August 2015 all who partook in *Ring of Fire* became symbols of the city and had a determining presence in the civic reality of what constitutes its culture and ideals. The police, Queen's Park, City Hall. All worked for us that day.[28]

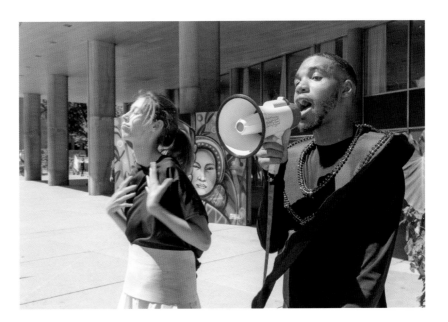

27 I don't know this as fact. The Mississaugas, however, seemed to think it was, which is good enough for me.

28 This cannot be underestimated as having a real impact on the civic lives of the collaborators, many of whom have never had a productive relationship with the city's administrative bodies— in particular the police—prior to this project.

The truth is in you and me. A fruit which nourishes our reality bittersweet. We read between the lines to find truth through all deception for genuine freedom.

I'm a man of humility. In search for the energy that has given me a different perspective on destiny. I survived my abnormalities only to blossom from such a tragedy.

Through the history of my people I have gained wisdom. I know who I am and that of my complexion. What has happened has only brandished my mind as a weapon.

But I'm honestly not aggressive. I'm courageously optimistic in my craft but distant from society. I'm fearful of my reality that in actuality I'm expressive.

I never found a love like this I have to admit. My instinct was to follow my interest and see where it goes. Who would've known this craft would make me whole.

In my respect I show nothing but peace, love and prosperity through the word. I respect my flaws because in all it caused me to grow in one aspect.

I'm aligned with the creativity of my forefathers. In my father's image I fall prince to his way of life. The way I read and the way I write. The way I exceed systematic stereotypes.

Of these traits I carry my weight as a starving artist, a mother's son and a father's image. Only to inherit the durability given to young princes. I await the throne in this virtuous kingdom.

—Kareem Bennett, "Moon"

Ring of Fire poster, 2015

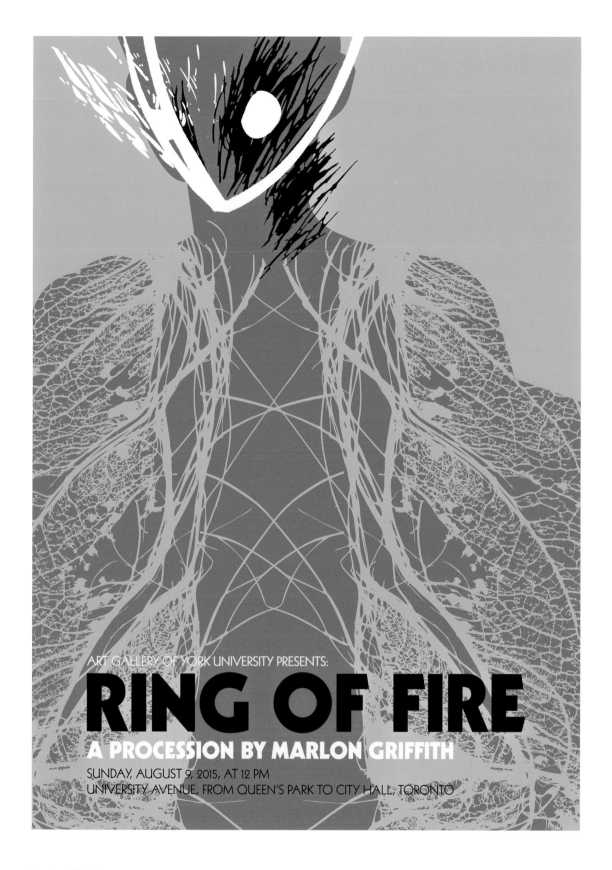

ART GALLERY OF YORK UNIVERSITY PRESENTS:

RING OF FIRE

A PROCESSION BY MARLON GRIFFITH

SUNDAY, AUGUST 9, 2015, AT 12 PM
UNIVERSITY AVENUE, FROM QUEEN'S PARK TO CITY HALL, TORONTO

Seven Grandfather Teachings Icons imagined and designed by Marlon Griffith, 2015

Symbols of Endurance

Symbols of Endurance

Art Gallery of York University (AGYU), Toronto
23 September – 6 December 2015

Below: The original leaf and seed that inspired the designs for the *Ring of Fire* costumes hang over a vitrine containing pages from Marlon's first site visit to Toronto in early 2014

Opposite and pp 140–141: Opening wall of Symbols of Endurance exhibition featuring the originating leaf pattern with two bronze casts made of the public masks in the procession; these bronze works were produced through the Louis Odette Sculptor-in-Residence Program, School of the Arts, Media, Performance & Design, York University

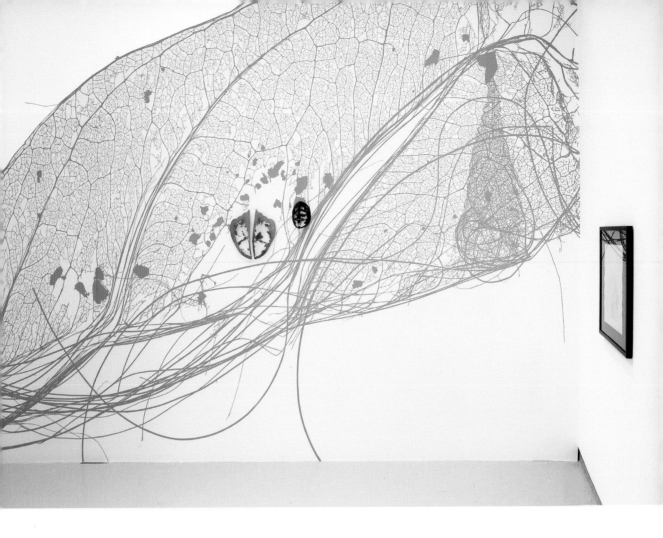

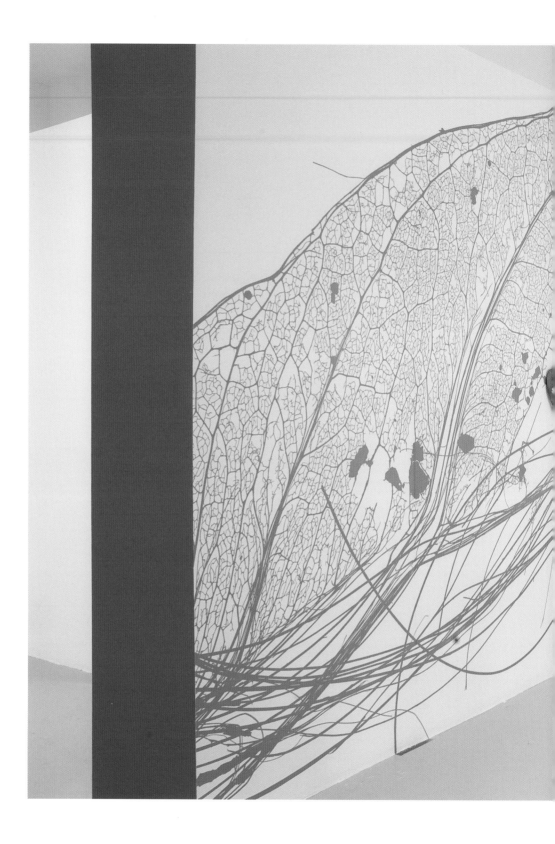

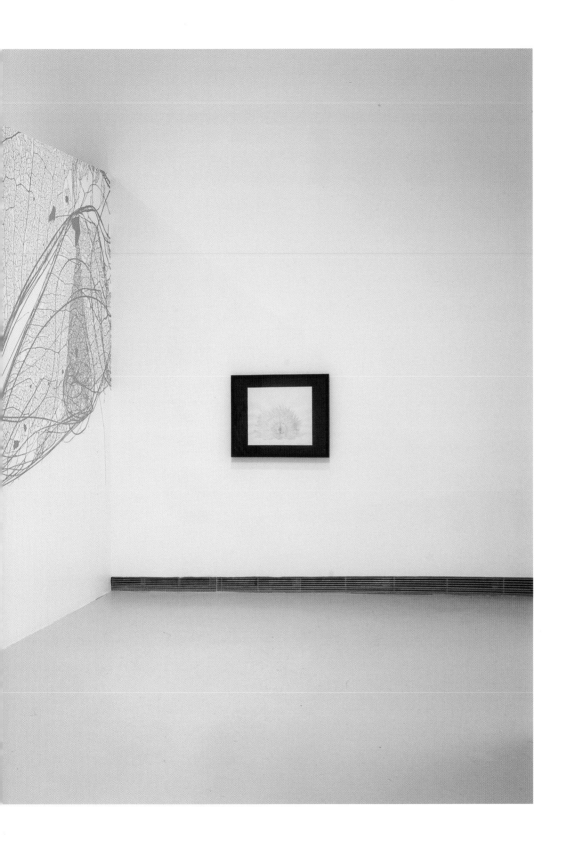

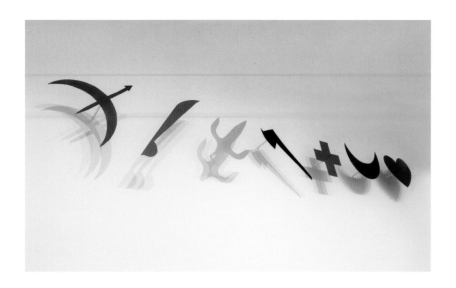

Left: Installation view of the "Orisha" symbols worn by members of the Humility Entourage, played primarily by capoeira practitioners; each of these seven Orishas corresponded to one of the Seven Grandfather Teachings

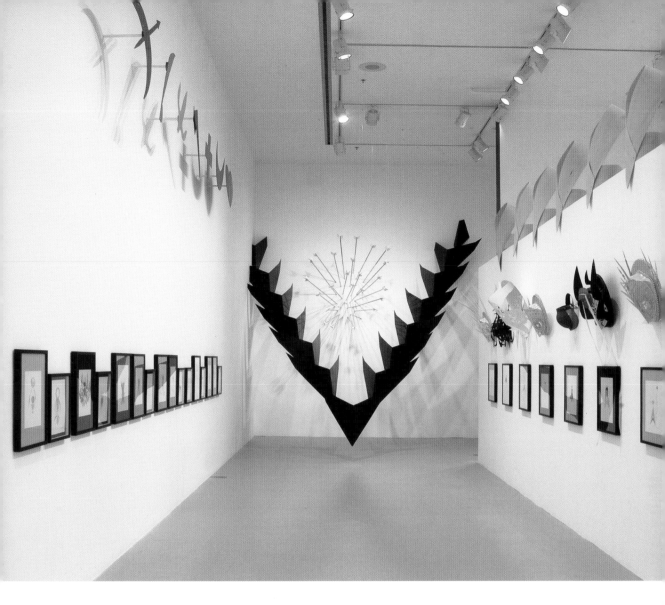

Above: Installation view of front gallery featuring a mixing of main costume elements from *Ring of Fire*; seen here are Humility (left, top), Courage (right, top), and Respect (back wall), alongside original watercolour drawings for Sentinels and Entourage (left) and Orators (right)

pp 144–45: Installation
view of Orator masks
with original watercolour
drawings of each costume
Opposite: The mask and
drawing for Truth Orator,
played in the procession
by Nadia Adow

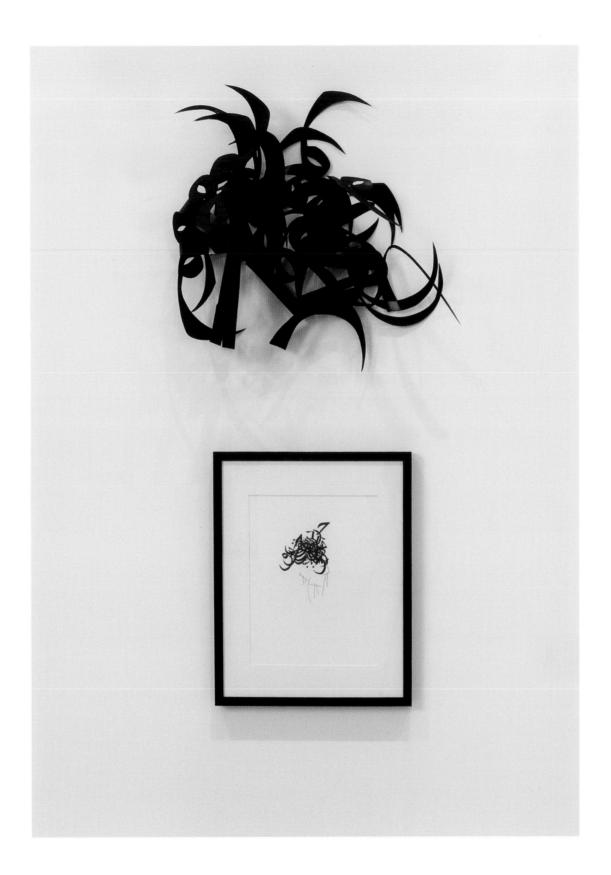

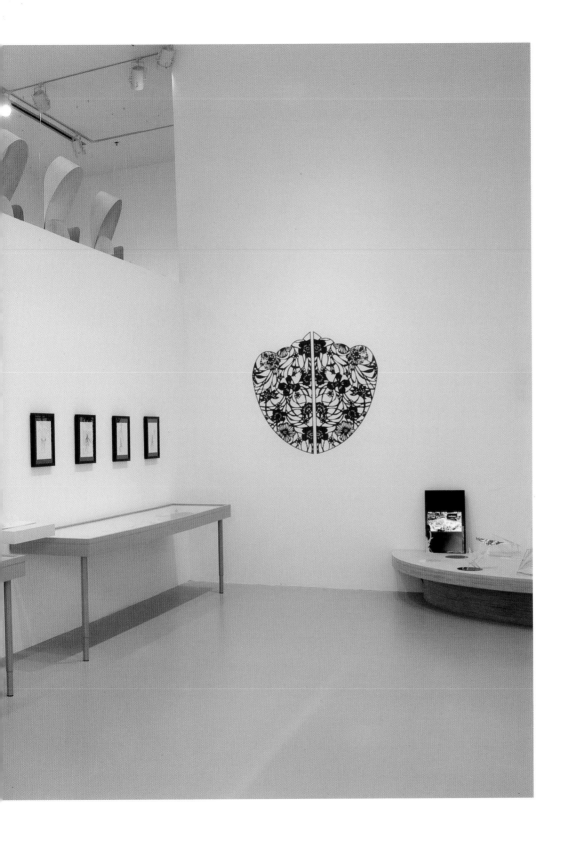

pp 148–149: Installation view of archival
room, which contained early sketches,
prototypes, maquettes, technical
drawings, mask templates, and
Marlon's sketchbooks

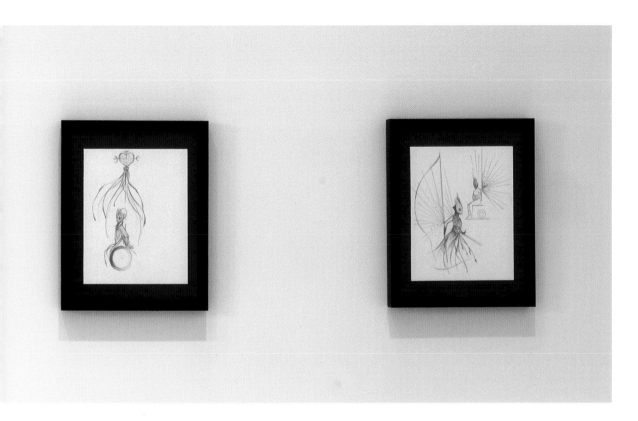

Left to right: *Ring of Fire: Honesty* concept drawing, 2015, graphite on paper; *Ring of Fire: Humility/Capoeira* concept drawing, 2015, graphite on paper; *Ring of Fire: Humility* concept drawing, 2015, graphite on paper; *Ring of Fire: Love* concept drawing, 2015, graphite on paper

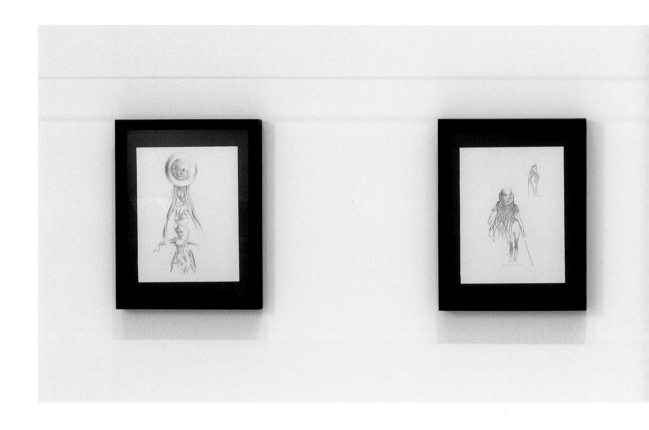

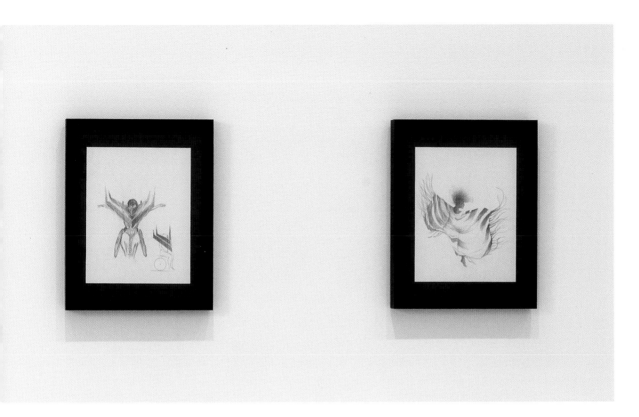

Left to right: *Ring of Fire: Wisdom* concept drawing, 2015, graphite on paper; *Ring of Fire: Courage* concept drawing, 2015, graphite on paper; *Ring of Fire: Respect* concept drawing, 2015, graphite on paper; *Ring of Fire: Truth* concept drawing, 2015, graphite on paper

Installation featuring
the maquettes for the
Sentinels and a video that
documented the round
dance finale at Nathan
Phillips Square, Toronto

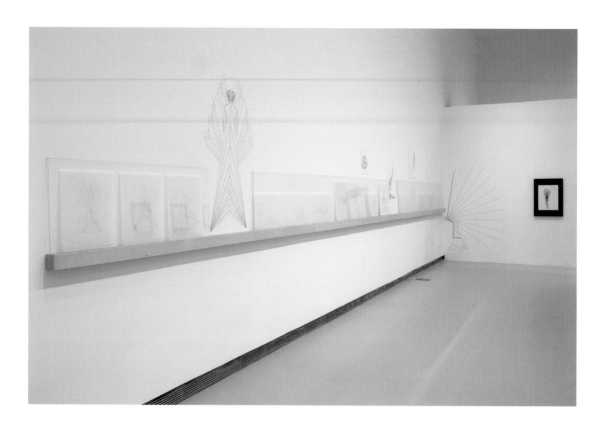

Above: Installation view of archival room featuring the technical drawings for large-scale Sentinel costumes
Opposite: *Ring of Fire: Love Sentinel/Melissa* technical drawing, 2015, cut vinyl

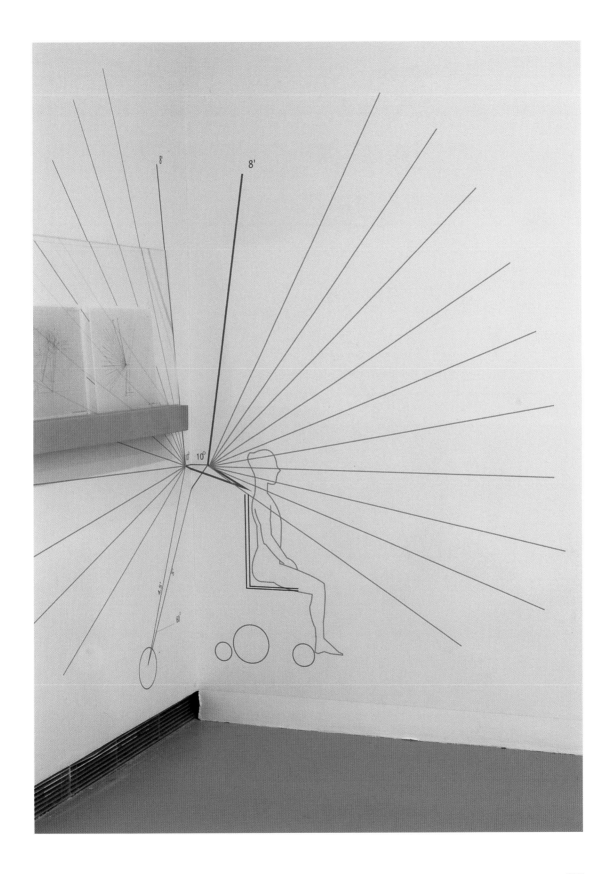

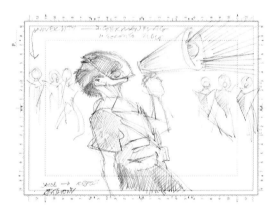

159

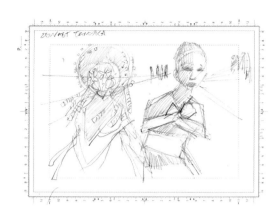

160

pp 158–161: *Ring of Fire: Procession Movement and Cues* storyboards, 2015, graphite and coloured pencil on paper

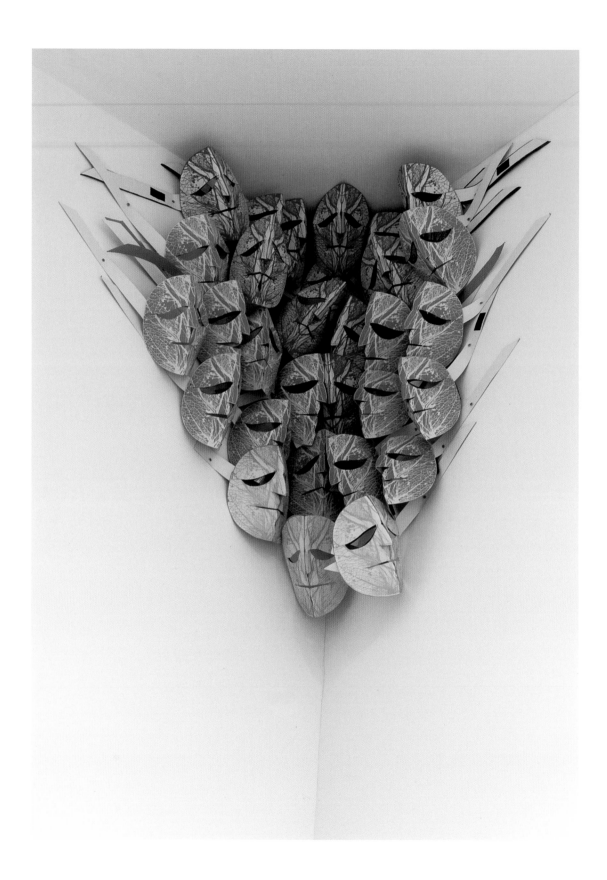

Opposite: An installation of one type of mask worn by public participants in *Ring of Fire* installed in the ceiling corner of the gallery

Below: Installation view of *Procession Movement and Cues* storyboards for the street procession and Nathan Phillips Square performance

pp 164–169: Installation view of immersive second gallery staging of elements from *Ring of Fire*, featuring two life-size projections shot from inside the procession; this room had a soundtrack that played alternating spoken word poems and songs based on the Seven Grandfather Teachings created by the Orators and the Mississaugas of the New Credit First Nation, respectively

pp 170–171: A silent, life-size projection of drone footage taken of *Ring of Fire*

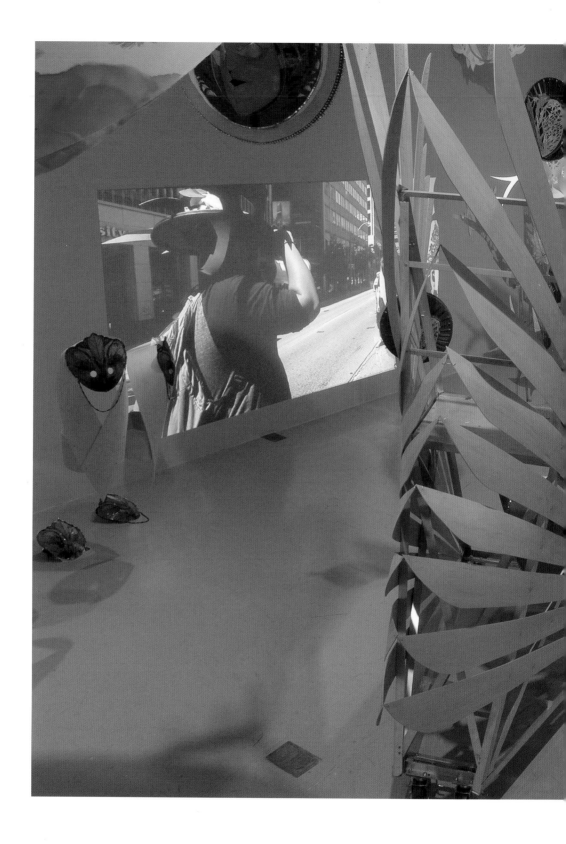

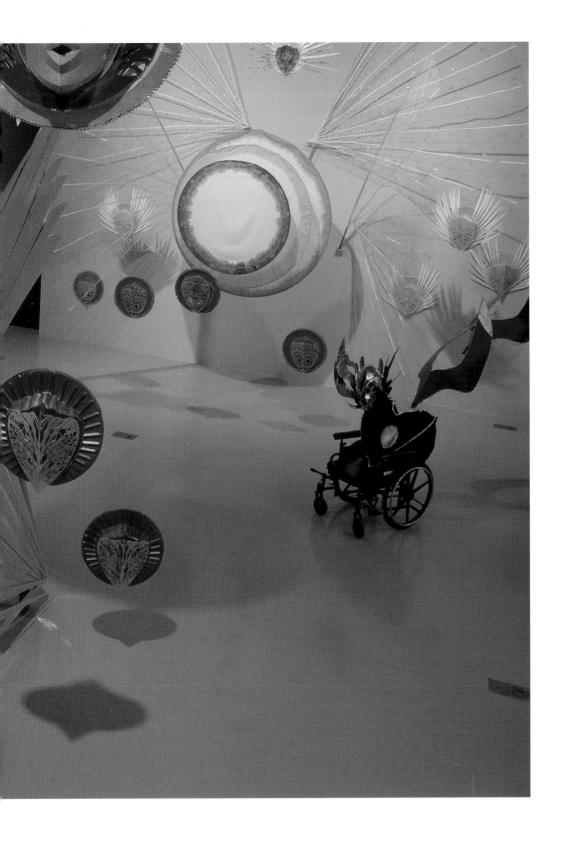

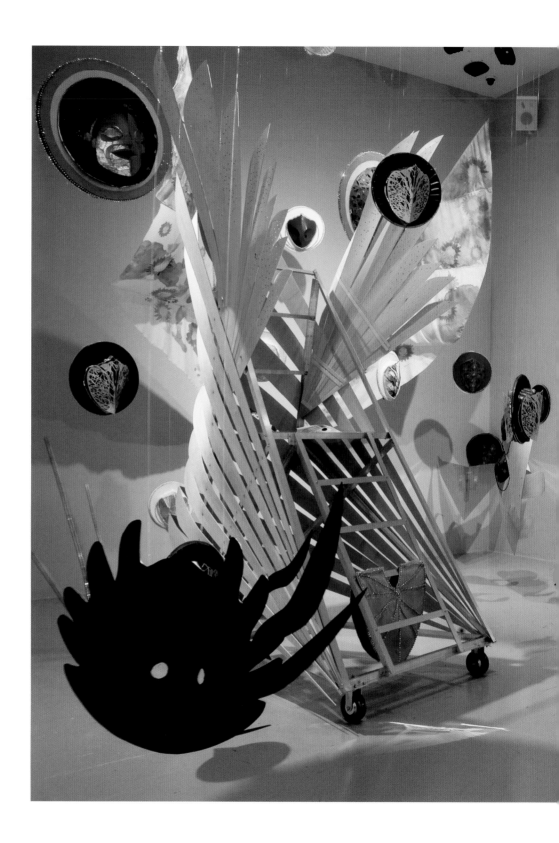

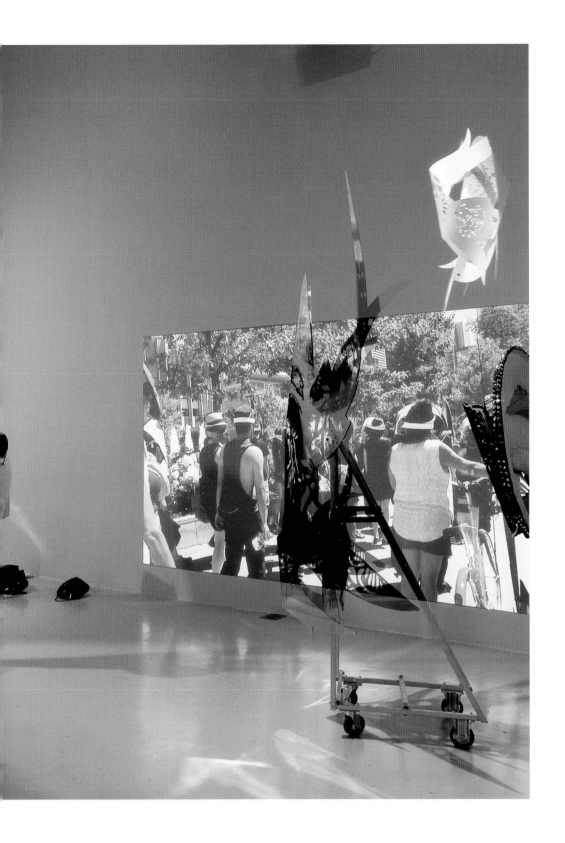

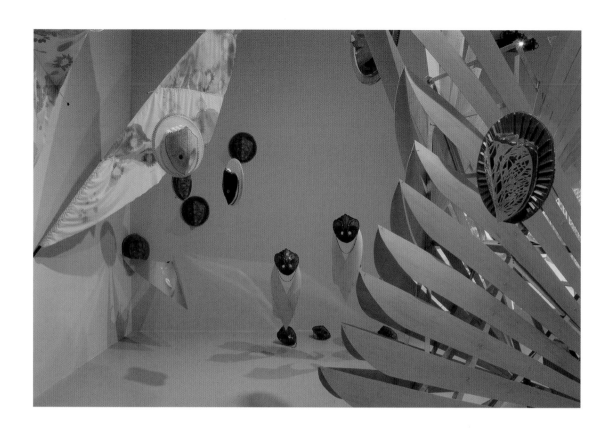

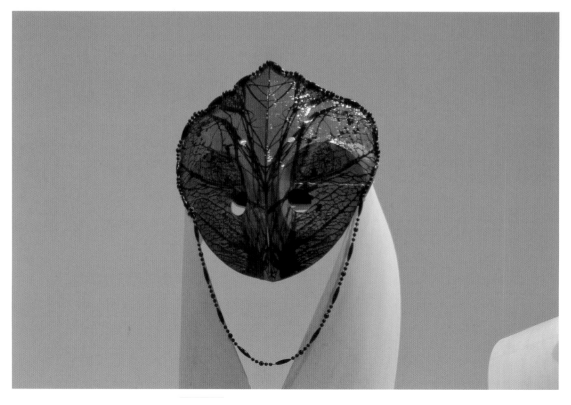

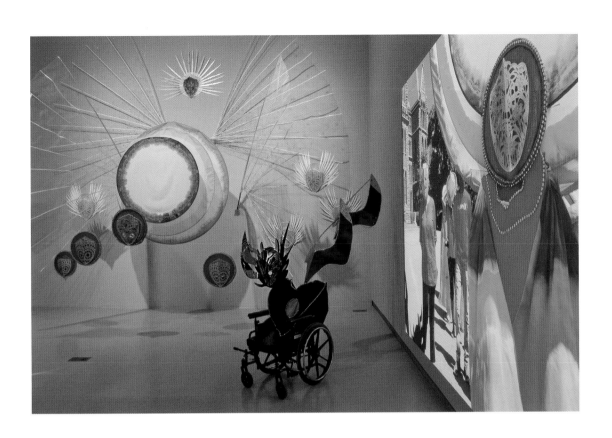

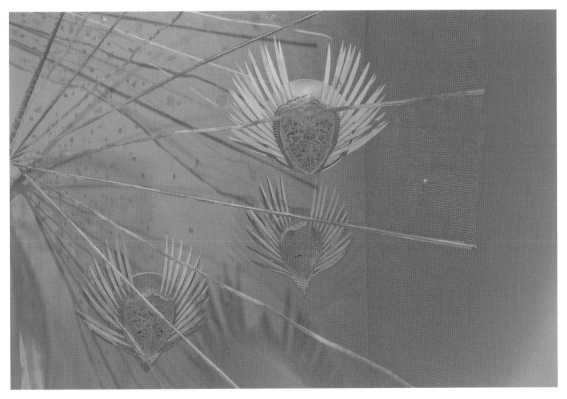

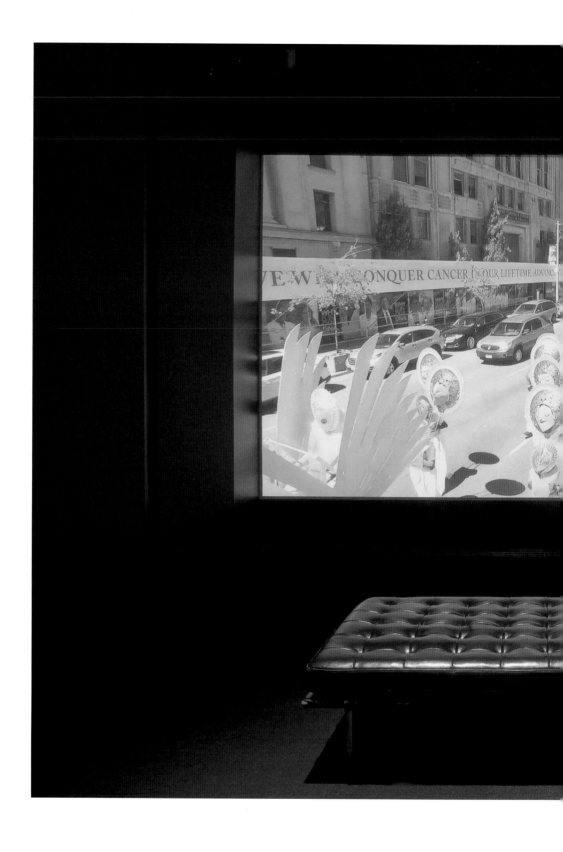

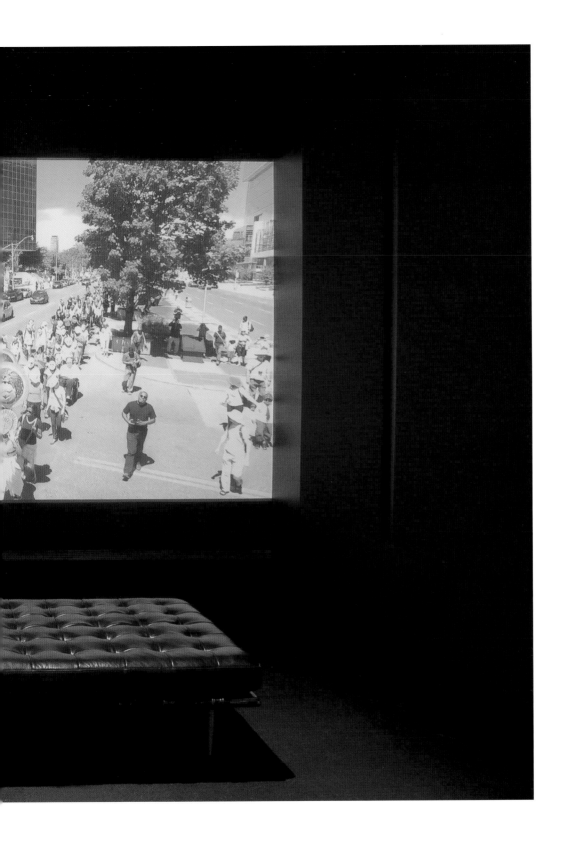

Photo Credits

Sara Angelucci: 77, 86 (top), 120 (top)
Jephté Bastien: 124
Julian Carvajal: 95
Karin Culliton: 85, 87 (bottom right), 90–93
Anthony Gebrehiwot: 80–83, 84 (top, middle), 94
Marlon Griffith: 20, 23, 25, 29, 33, 38–40, 44, 45, 47 (top), 49, 50, 52, 53, 100 (bottom right), 101 (bottom), 114 (top), 115 (bottom), 123 (bottom left), 125, 127 (top)
Marlon James: 31 (top), 48, 71–73
Takeshi Nagao: 6
Noel Norton, courtesy Callaloo Company: 54
Cheryl O'Brien: 138–171
Akiko Ota: 9–19, 37, 69–70
Georgia Popplewell: 47 (bottom)
Sonya Reynolds: 133
Grahame Singleton: 36
Maju Tavera: 31 (bottom), 78–79, 84 (bottom), 86 (bottom), 87 (top, bottom left), 88–89, 96–97, 100 (all but bottom right), 101 (top), 104–105, 110–111, 115 (top), 123 (all but bottom left), 127 (bottom), 129, 131 (bottom), 132
Mark Wessels: 66, 67

All other images courtesy the artist.
Illustration courtesy Archives of Ontario: 74
Poster designed by Ken Ogawa: 135

Acknowledgements

Ring of Fire curator Emelie Chhangur and artist Marlon Griffith would like to thank: Melissa Addison-Webster, Allyson Adley, Nadia Adow, Jacob Agustin, Zeinab Aidid, Alternative Roots, Katie Anderson, Sara Angelucci, Patricia Araya, Donald Barrie, Jephté Bastien, Kareem Bennett, Bidhan Berma, Sheila Boyd, Sandra Brewster, Mark Brose, Amefika Browne, Tamyka Bullens, Cherith Burke, Renee Burnett, Percy Campos, Suzanne Carte, Julian Carvajal, Sarah Christoper, soJin Chun, Emily Clarke, Michelle Clarke, Sue Cohen, Crystal Media, Samantha Cutrone, Karin Culliton, Samantha Cutrone, Sophia Daley, Loren Delaney, Jega Delisca, Julian Diego, Katherine Earl, Meirav Even-Har, Alysha Faubert, Patrick Faucher, Barbara Fischer, Wanda FitzGerald, Liz Forsberg, De Vaughn Francis, Anthony Gebrehiwot, Gaétan Genesse, Geoffrey Gilmour-Taylor, Mark Green, Derek Grey, Rose Gutierrez, Tamara Haberman, Taylor Hammond, Destiny Henry, Zoë Heyn-Jones, Makayla Hill, Torrance Ho, the Drake Hotel, Douglas Hurst, Scout Huston, Amanda Hyde, Hafsa Isse, Rose Jacobson, Keisha James, Cathie Jamieson, Veronica Jamieson, Jordan Jamieson, Calvin Jamieson, Isha Joshi, Reena Katz, Da Jeong Kim, Rachel King, Rachele King, Caroline King, Tyrell King, Kelly Laforme, Daniel Lastres, Krista Lee-Bath, Jennifer Lees, Mariana Maciel, Michael Maranda, Nicole Marcano, Kit McAllister, Durelle Harford McAllister, Anna MacLean, Rea McNamara, Tabitha McNaughton, Marcio Mendes, Dawn-Marie Maiato, Philip Monk, Minna Muralles, Sumaira Naz, Mia Nielson, Johnson Ngo, Thuy Nguyen, Marwa Normohamad, Phyllis Novak, Abdulkarim "Moose" Nur, Michael O'Connell, Ken Ogawa, Alexis Pastuch, Karen Pellegrino, Chaad Pierre, Juan Pablo Pinto, Poesis Media, Yulia Prudova, Natalia Pushkar, Tatiana Ramos, Duke Redbird, Cassie Rehman, Hope Rehman, Sonya Reynolds, Megan Rigelhof Norwick, Faith Rivers, Carleen Robinson, Shannon Saint, Harpreet Sandhu, Andrew Shaver, Susan Shaw, Rachel Sheinin, Beverly Smith, Roch Smith, Veronica Stevens, Suviana, Maju Tavera, Andrew Tay, Daniel Thompson, Tevin Thompson, Darryl "Thunderclaw" Robinson, Andrae Treleven, cheyanne turions, Brandon Vickerd, Raven Waters, Joel Wengle, Anna Wren, Kevin Yates.

Ring of Fire was generously supported by the Ontario Arts Council, IGNITE Ontario and IGNITE Toronto, Ontario Trillium Foundation,

Toronto Arts Council, School of the Arts, Media, Performance & Design at York University, and through the passion and commitment of every individual and organization involved in the project. Mas' camps were produced by AGYU in collaboration with Art Starts & the Lawrence Square Shopping Centre and SKETCH; Music workshops in collaboration with Alternative Roots and the SKETCH Band; movement workshops in collaboration with SKETCH, Picasso PRO, and Capoeira Angola. AGYU's year-long spoken word poetry program was developed in partnership with The Malvern S.P.O.T, Success Beyond Limits and COBA with support from the Honey Family Foundation and the Vital Toronto Fund at the Toronto Foundation and the Toronto Arts Council: Targeted Enhanced Funding. Special thanks to Community Living Toronto for in-kind support of *Ring of Fire* and Strathcona Paper LP for donating the paperboard material for masks. Thank you to the Ontario Legislative Assembly, Toronto Police Services, and 52 Division of the Toronto Police.

Marlon Griffith would like to thank the following individuals: Stacey Laforme, David Perrett, Caroline Pêtre, Lydia Sayeau, Don Shipley, Jeremy Stellato, and Matthew Visser-Charest for their aid in the process of putting together *Ring of Fire*.

And the following organizations: Alice Yard, the Bag Factory, Commonwealth Foundation, Culturesfrance, Elimu Mas Band, Granderson Lab, John Simon Guggenheim Memorial Foundation, Mino Paper Art Village, and the Prince Claus Fund.

As well, he would like to thank the following individuals for ongoing support: Akiko Ota-Griffith, Kikuo and Fumiko Ota, the Griffith family, Emelie Chhangur, Christopher Cozier and Irénée Shaw, Ian and Leona Benjamin, Gerard Gaskin, Jaime Lee Loy, Nikolai Noel, Cécile Pemberton, Claire Tancons, and Marlaine Tosoni.

This publication was made possible through the generous support of Partners in Art (PIA), for which we are grateful.

© 2017 Black Dog Publishing Limited, the authors and the artist.
All rights reserved.

Black Dog Publishing Limited
10A Acton Street, London WC1X 9NG
United Kingdom

t. +44 (0)207 713 5097
f. +44 (0)207 713 8682
info@blackdogonline.com
www.blackdogonline.com

All opinions expressed within this publication are those of the authors
and not necessarily of the publisher.

British Library Cataloguing-in-Publication Data.
A CIP record for this book is available from the British Library.

ISBN 978 1 911164 04 3

No part of this publication may be reproduced, stored in a retrieval
system, or transmitted, in any form or by any means, electronic,
mechanical, photocopying, recording, or otherwise, without prior
permission of the publisher.

Every effort has been made to trace the copyright holders, but if any
have been inadvertently overlooked the necessary arrangements will
be made at the first opportunity.

Black Dog Publishing is an environmentally responsible company.
Marlon Griffith: Symbols of Endurance is printed on sustainably
sourced paper.

The Art Gallery of York University is supported by York University,
the Canada Council for the Arts, the Ontario Arts Council, and the
City of Toronto through the Toronto Arts Council.

art design fashion
history photography
theory and things

www.blackdogonline.com